Contents

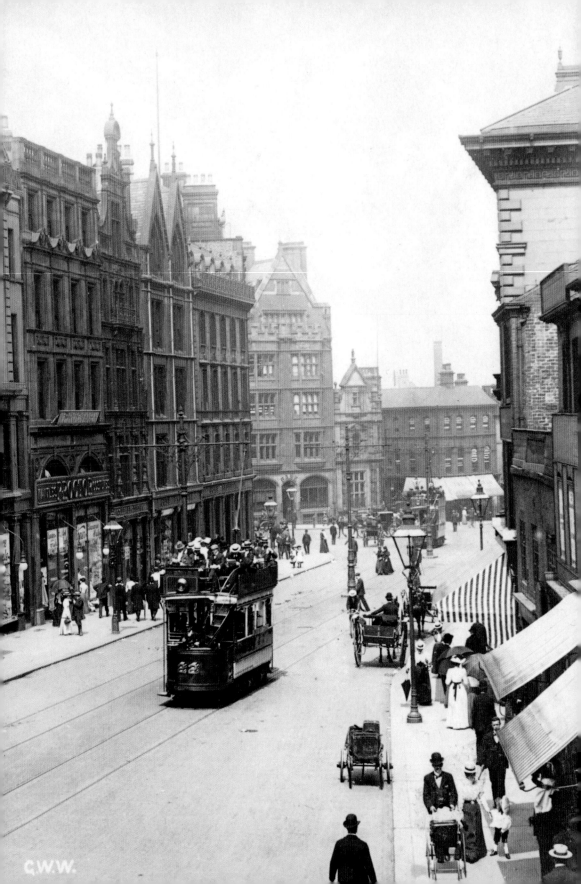

C.W.W.

Historic England

Sheffield

Ian D. Rotherham & Christine Handley

AMBERLEY

First published 2018

Amberley Publishing
The Hill, Stroud, Gloucestershire, GL5 4EP
www.amberley-books.com

ISBN 978 1 4456 8368 3 (print)
ISBN 978 1 4456 8369 0 (ebook)

Origination by Amberley Publishing.
Printed in Great Britain.

Introduction

The city of Sheffield is known around the world for steel, cutlery and, sadly, at one time, significant pollution. However, in more recent times the image of the 'dirty city in a golden frame' has changed to one of a green, thoroughly European, metropolitan city famed for its eighty or more ancient woods and remarkable green spaces. Cheek-by-jowl with the Peak District National Park and indeed with around a third of the city actually in the park, Sheffield is now badged as the 'City of the Great Outdoors'. Boasting world-class sporting and leisure facilities, two major universities, major professional football clubs, and even the notable Meadowhall Shopping Centre, the city's transformation has been dramatic. The region boasts numerous splendid parks and gardens, and over twelve major nature reserves where in the 1970s there were none.

There is still industry and a major presence of specialist steel manufacture and the advanced technology and engineering initiatives in partnership with the universities. However, the economic base of Sheffield and its wider region has diversified over the last thirty years or so. Tourism, for example, is now a major part of the economic pulse of the city and much of this is driven by visitors and students drawn by the two universities.

Sheffield has also developed an enviable reputation for media and the arts, with popular music especially coming to the fore. Groups and performers such as the Arctic Monkeys, Human League, Heaven 17, ABC, Pulp, Richard Hawley, Dave Berry, Tony Christie, and even Jilted John (!) have put Sheffield firmly on the global soundtrack. Films such as *The Full Monty*, *Among Giants* and *Brassed Off* (focused on Barnsley in the wider city region) presented Sheffield in the stark post-industrial era, and built on earlier forays such as Kes (on the Barnsley/Sheffield edge). On the western moors and surrounding areas, and with gems such as Chatsworth House close by, films like *Pride and Prejudice* and *Death Comes to Pemberley* have helped establish the city region as a good place to make movies.

Excellent theatres such as the Lyceum and the world-famous Crucible combine with smaller venues and major concert arenas to provide a wide range of entertainment to suit all tastes. But above all else, perhaps, Sheffield has a great reputation as a warm, welcoming and hospitable place and is a richly diverse and multicultural city. That the conductors and drivers on buses and trams call you 'love' is merely a bonus that you have to grow accustomed to.

The city that gave the world stainless steel and Sheffield plate has reinvented itself by repurposing its industrial heritage as apartments, bars and restaurants as well as creating new workspaces for designers, craftspeople and makers. It has replaced the large breweries that quenched the thirst of steelworkers with a plethora of microbreweries that pepper former industrial areas like Kelham Island and serve a new generation of real ale pubs, which attract visitors from across the country.

City Centre

Sheffield city centre developed from the old medieval town, with its nucleus being from the Parish Church of St Peter and St Paul, Barker's Pool and Fargate through the market areas and down to the old castle. By the eighteenth century new commercial, residential and industrial areas were being set out, which began the town centre's major expansion into the surrounding rural hinterland.

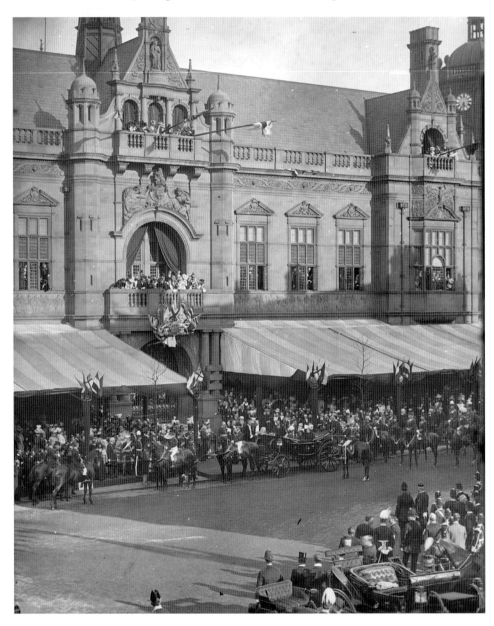

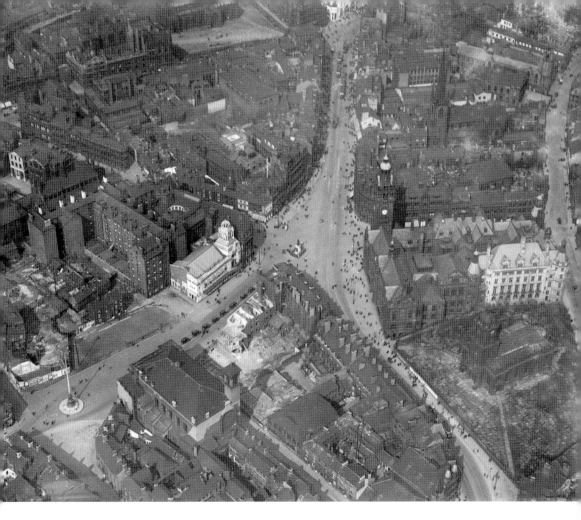

Above: Barker's Pool and Fargate, 1926
This view in 1926, with the war memorial in Barker's Pool to the bottom left, looks down Fargate towards High Street. Most of the buildings show the dirt and grime of the city centre at that time. The lighter-coloured building on the right of the picture stands out in contrast. This was the newly completed extension to the 1897 Town Hall (completed in 1923), which included a new rates hall and office space. Today part of the building houses the Registry Offices. (© Historic England Archive. Aerofilms Collection)

Opposite: Queen Victoria Outside Sheffield Town Hall During the Official Opening in 1897
Taken from Pinstone Street during the official opening of Sheffield Town Hall in 1897, this view shows the elderly Queen Victoria in her carriage outside the main west entrance. The front of the building is still easily recognised apart from the awnings to protect the local dignitaries. (Reproduced by permission of Historic England Archive)

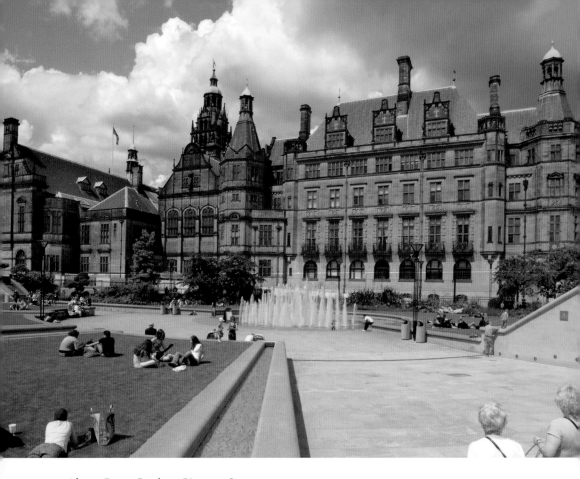

Above: Peace Gardens, Pinstone Street
This area adjacent to the Town Hall was re-landscaped at the turn of the millennium. Originally known as St Paul's Gardens after St Paul's Church that stood alongside, it became known by Sheffielders as the 'Peace Gardens' because it was created at the same time as Chamberlain returned from Germany with the Peace Treaty. Today the more formal flower beds and rose gardens have given way to water features and wide paths. The gardens, shown here in 2004, are now a venue for street markets and festivals throughout the year. (© Historic England Archive)

Opposite below: The Old County Court, Bank Street
Shown in 2001, the former county court building on Bank Street was opened in 1854. This was the forerunner of the county court building on the corner of Castlegate and is easily identifiable by the crest on the front of the building. This view also shows the side of the building and the steep lane down to West Bar, where the new court buildings are now situated. (© Historic England Archive)

The Old Town Hall, Castle Street
Built in three phases between 1807 and 1897, the building also accommodated the petty and quarter sessions courts. It replaced an earlier town hall, sited at the junction of Church Street, High Street and Fargate. It was enlarged in 1833, but because of lack of space the council moved to a new Town Hall, which was built in 1897. The Old Courthouse was the county court for Sheffield until 1997. (© Historic England Archive)

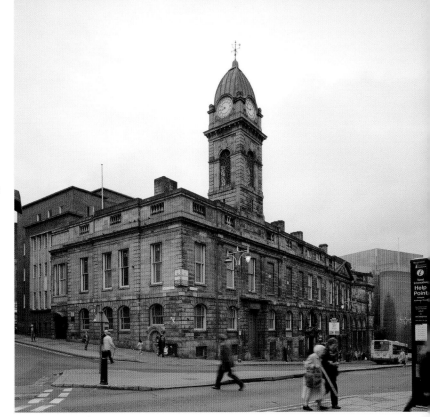

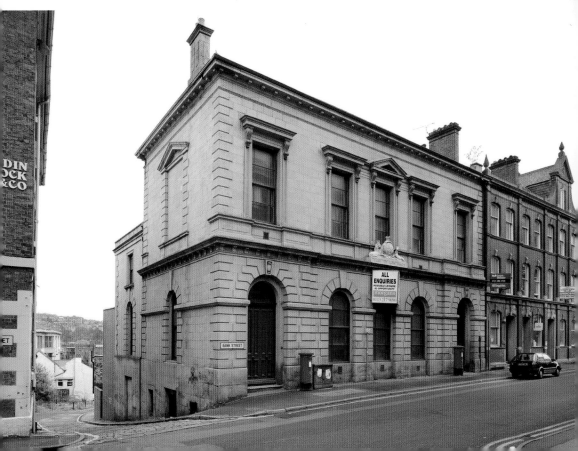

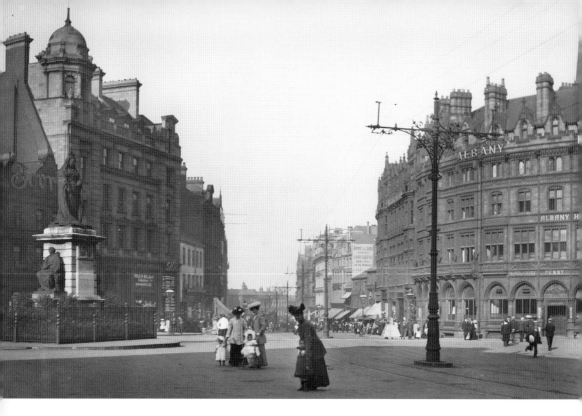

Fargate

Taken in the early twentieth century (around 1910–20), this view looking down Fargate is very similar today. However, the statue of Queen Victoria (on the left), erected to celebrate her Golden Jubilee, and the overhead tram power supply on the right are no longer there. The 1897 Town Hall would be situated to the right and off the picture. (Reproduced by permission of Historic England Archive)

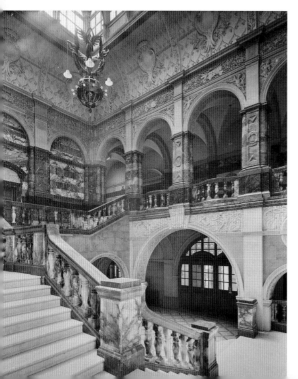

The Town Hall's Grand Staircase

The interior of the Town Hall (the grand Victorian creation) is impressive. This view of the main staircase inside the Grade I-listed Town Hall was taken in 1897. It shows the ornate design made from grey and brown Devon marble with a balustrade of alabaster. The stairs lead to a superb extended balcony, off which are meeting rooms and reception rooms. (Reproduced by permission of Historic England Archive)

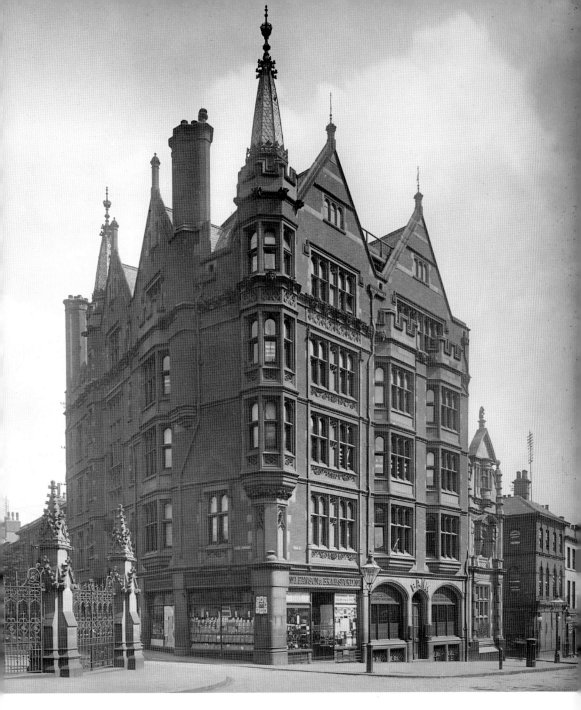

Pawson & Brailsford Buildings

Built in the late nineteenth century for the commercial printing business of Pawson & Brailsford, this building (seen here in 1897) was also known as Parade Chambers. The upper floors were occupied by solicitors and accountants, with Pawson & Brailsford's shop on the ground floor. The gargoyles and other decoration echoed the parish church (later the cathedral), which it is next to. It includes a carved panel with the inscription 'P&B 1883'. (Reproduced by permission of Historic England Archive)

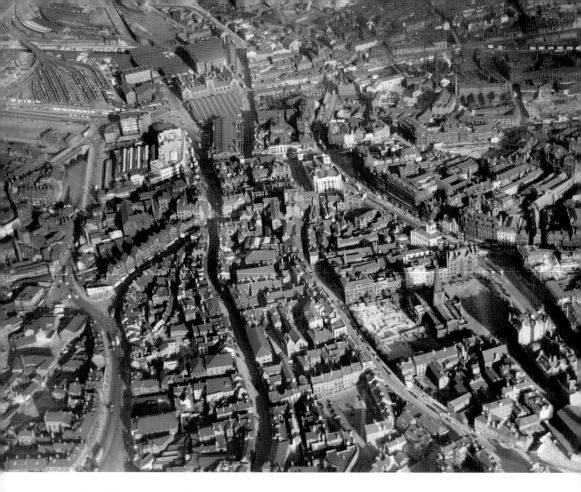

Above: Campo Lane and Environs
This 1937 image of the area around Campo Lane shows a densely packed city centre that was soon to change. Much of the area across the centre of the picture was destroyed during the Blitz in 1940. Some parts, however, are still recognisable today. Paradise Square, with its Georgian buildings, can be seen in the bottom middle of the picture and the Cathedral Church of Saints Peter and Paul, although now altered, can be see just above to the right. The area at the bottom left is now the site of the county and family courts. (© Historic England Archive. Aerofilms Collection)

Opposite above: Cutlers' Hall, Church Street
The classical-style building was opened in 1832 and a large banqueting hall was added in 1857. It is the third Cutlers' Hall to stand on the site and was built by the Company of Cutlers in Hallamshire, which was founded in 1624 and grew to represent the business and commercial success of the town, and later the city. It is pictured in 2004.

Opposite below: Nos 210–214 West Street
The Cavendish Buildings, which occupy Nos 210–214 West Street, were built in 1910. The striking repeated design of different-coloured bricks, large windows and the distinctive roofline dominates this part of West Street. This general view from 2011 shows the corner of the building, which was built at an angle to the main street. (© Historic England Archive)

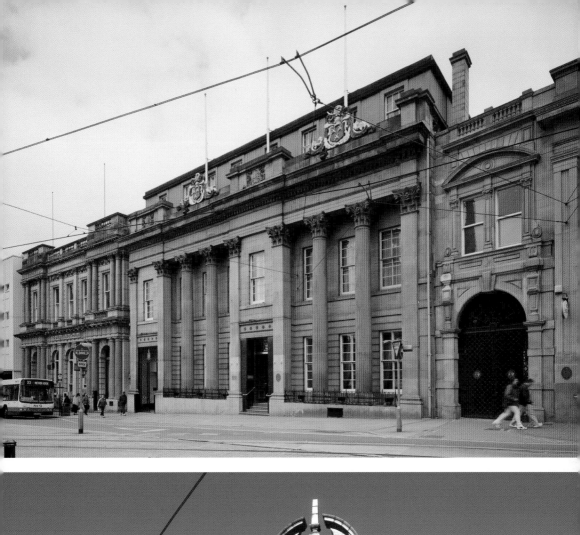

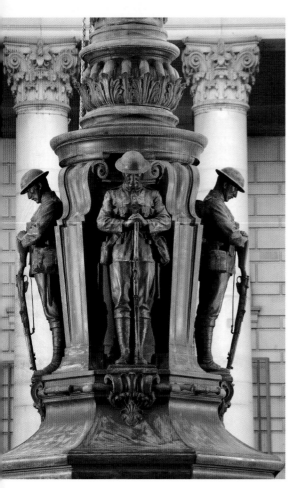

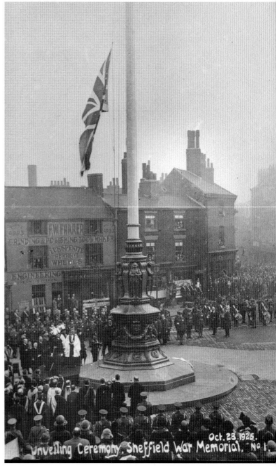

Above left: War Memorial, Barker's Pool
The sculpted figures on the war memorial in Barker's Pool commemorate those who lost their lives in the First World War. At the unveiling ceremony the first wreath was laid by Mayor A. J. Bailey. The memorial has been the focus of Sheffield's remembrance services since then and new plaques have been added around the base. It is pictured here in 2016. (© Historic England Archive)

Above right: War Memorial Unveiling Ceremony, 1925
The war memorial in Barker's Pool was unveiled by Lieutenant General Sir Charles Harrington, GOC Northern Command on 28 October 1925. Weighing 10 tons and approximately 35 metres long, the hollow steel mast was erected in August of the same year. Crowds of people are shown here as they witness the unveiling ceremony. (Reproduced by permission of Historic England Archive)

Fitzalan Square and City Centre

A view of Fitzalan Square and the statue of Edward VII. The central GPO building behind the statue is almost in the centre of this image. Taken in the early 1950s, this picture shows scaffolding marking the site of Walsh's department store (middle right) being rebuilt after sustaining heavy damage during the Blitz in 1940. The building now sits on the corner of Arundel Gate and High Street, and still houses shops. The Marples Hotel, which sat on the cleared site to the right of Fitzalan Square, suffered a direct hit during the Blitz and seventy people lost their lives as a result. The large, pitched roofed building in the bottom left of the image was the Norfolk Market Hall, which was demolished in 1959 to make way for the new Cattle Market. The image also shows the earlier street pattern and many of the old buildings that were demolished in the 1960s to make way for a new modern cityscape with the short-lived 'Hole in the Road' and later Supertram. (© Historic England Archive. Aerofilms Collection)

Left: The Triumphal Arch
Triumphal arches were temporary structures built as part of celebrations linked to royal visits. This example, on Lady's Bridge, was erected in 1875 for the visit of the Prince of Wales (future Edward VII). Others were created at key points along major routes into or through the then town, along which the royal visitor would pass. (Reproduced by permission of Historic England Archive)

Below: Central Fire Station
This imposing building on Division Street, photographed in 1991, is now residential flats on the upper floors and a bar on the ground floor. Its frontage was built in the 1920s, extending the old Rockingham Street fire station and creating the new Central Fire Station, which opened in 1929. The large doors and area where the fire engines were housed are still evident, as is the name on the lintel above. (© Crown copyright. Historic England Archive)

Industry

Famous for its cutlery, iron and steel manufacture, Sheffield's industries developed from the eighteenth century along the Don and Sheaf valleys, creating huge factory sites by the beginning of the twentieth century. This was made possible by coal and steam power, which superseded water-powered mills situated along Sheffield's river valleys. Water power triggered the early development of Sheffield's industrial activities.

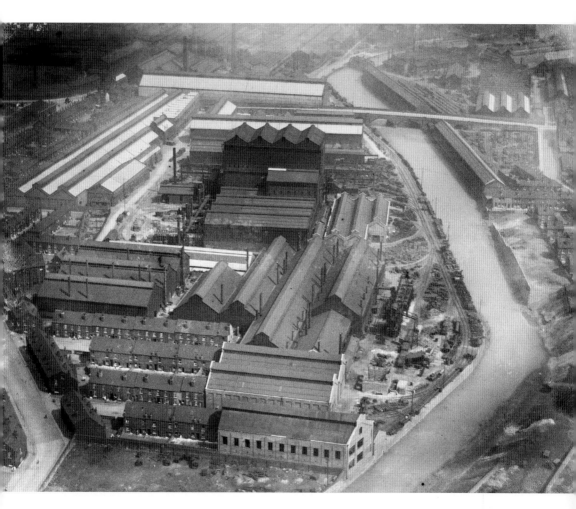

Vickers Works
Taken in 1922, this image shows the complex of factory buildings making up the Vickers Works. Originally known as the new Don Steelworks, the factory was built at Brightside for Sir Edward Vickers in 1867 after his company had outgrown their former home, the 'old' Don Steelworks at Millsands. This became one of the major industrial centres for the emerging city. (© Historic England Archive. Aerofilms Collection)

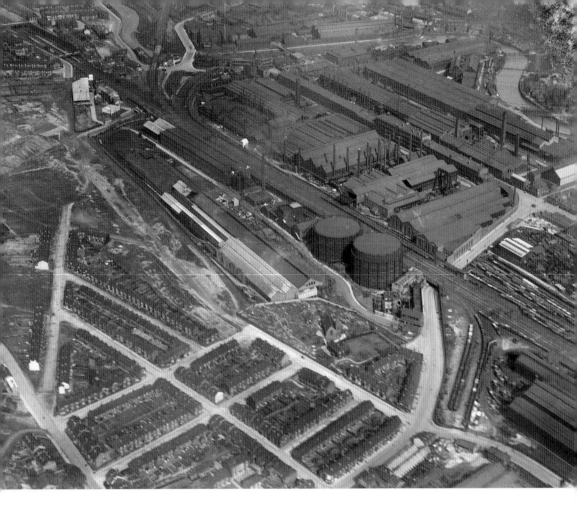

Above: Grimesthorpe Gasworks and River Don Armour Plate Works
The River Don Armour Plate Works in the Grimesthorpe area of Sheffield is at the top right of this 1926 image. It was owned by the Cammell company and was one of the leading manufacturers of toughened plate steel used in shipbuilding. Sheffield was a centre for rolled armour plate for battleships and for military vehicles. (© Historic England Archive. Aerofilms Collection)

Opposite above: Atlas and Norfolk Steelworks
Taken in 1989, this view of the Atlas and Norfolk Steelworks taken from Carlisle Street East shows the structure of some of the older buildings in the industrial complex. It was taken at a time of great change in the industry when many of the factories closed and were then demolished. Essentially, photographs like this capture Sheffield's industrial heritage at a time when it was evolving, and in some cases being obliterated. (© Crown copyright. Historic England Archive)

Opposite below: Sipelia Works, Cadman Street
Taken in 1989, this image of the Sipelia Works is taken on Cadman Street, which leads off Lumley Street and crosses over the canal. This building still exists and is now workshops and the headquarters of the Emmaus Society. It is typical of the imposing main entrances to many of the other works housing expanses of buildings. (© Crown copyright. Historic England Archive)

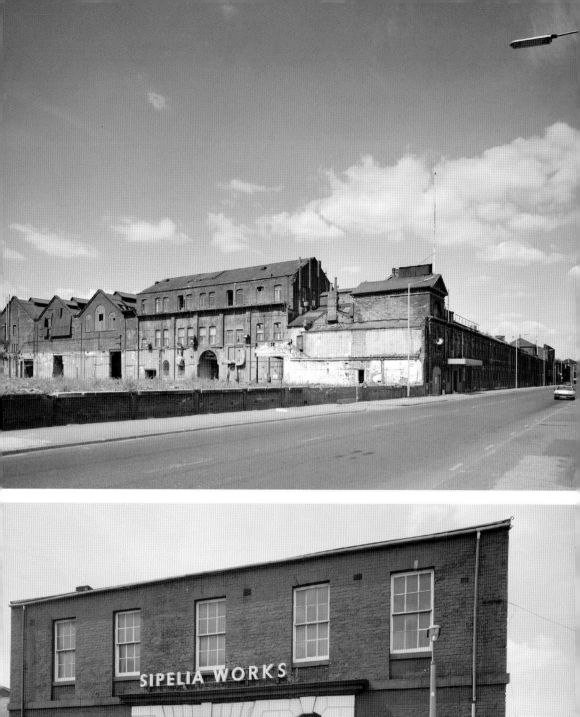

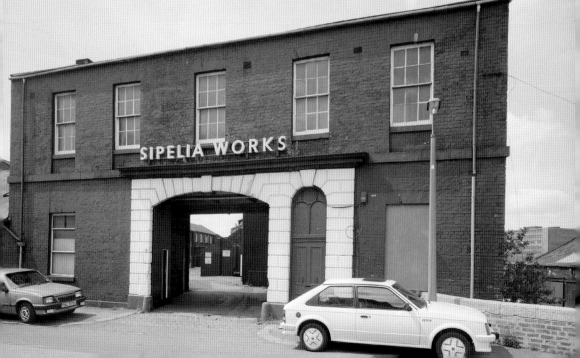

SIPELIA WORKS

Abbeydale Industrial Hamlet
Pictured in 2001, the Abbeydale Works is an eighteenth-century industrial complex with a crucible furnace and scythe works. It operated until the mid-twentieth century and was turned into an industrial museum in the 1970s. This view shows the crucible furnace. The crucible steel-making process was developed by Huntsman in the mid-eighteenth century to produce high-quality steel. (© Historic England Archive)

Eye Witness Works
Taken from the Beehive Works, this 2001 view looks north-east towards the Eye Witness Works on Milton Street. The Eye Witness Works is a Grade II-listed building and a typical example of a nineteenth-century cutlery works. It was named Eye Witness because of the cutler's mark of an open eye granted to John Taylor in 1838. The works latterly specialised in table knives, although scissors and pocket knives were also made here.

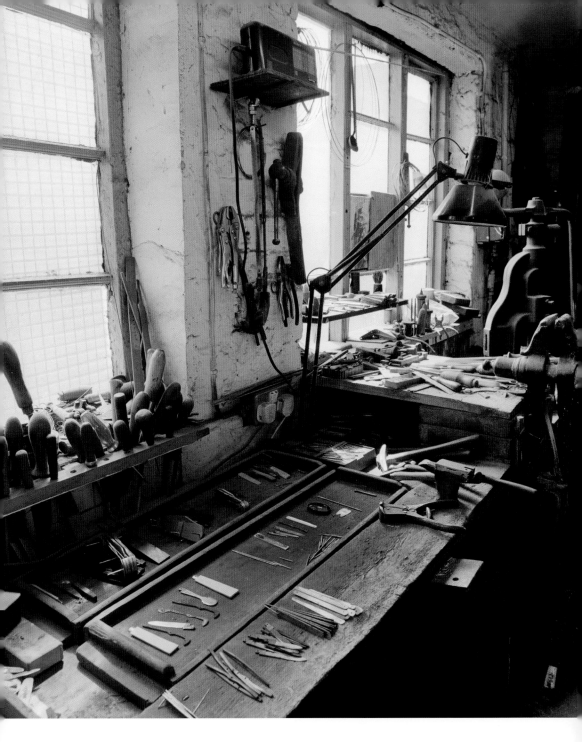

Workbench on Garden Street
Taken in 2001, this is a view of Stan Shaw's workbench in his workshop on Garden Street, and is typical of a 'little mester's' workshop. It shows some of the range of tools that were used.

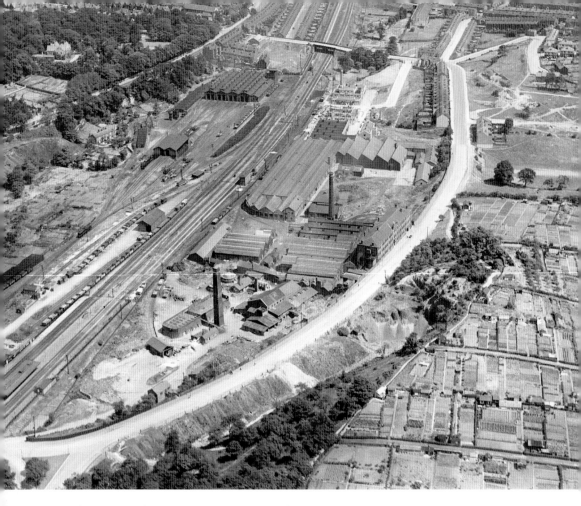

Above: Laycock Engineering's Victoria Works
Taken in 1932, this view of Laycock Engineering's Victoria Works at Archer Road in the Sheaf Valley, Millhouses, shows it in a semi-rural setting. The company was set up to make components for railway rolling stock and later components for the automotive industry. This was one of a number of major steelworks extending out to the west along the River Sheaf. (© Historic England Archive. Aerofilms Collection)

Opposite above: Mappin & Webb's Royal Works
Mappin & Webb's large Royal Works and showroom on Queens Road is shown in the centre of this image from 1939, just prior to the war. The company was one of the leading Sheffield manufacturers of silver and silver-plated tableware, employing hundreds of people including many skilled craftspeople. At the time Sheffield was the world-leading centre for such products. (© Historic England Archive. Aerofilms Collection)

Opposite below: The Gun Shop, West Works
This modern image from 2001 shows another of the steelworks complexes of buildings that used to line both sides of Savile Street East. This is a view of the Gun Shop, West Works, another of the factories involved in producing heavy armaments for the military during the two world wars.

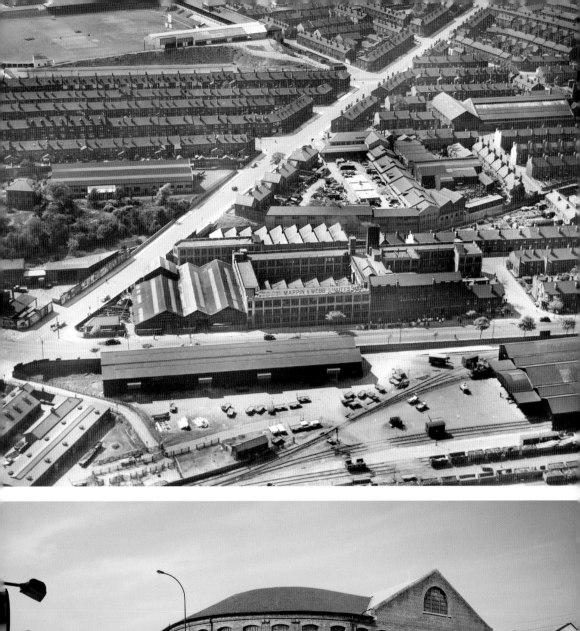
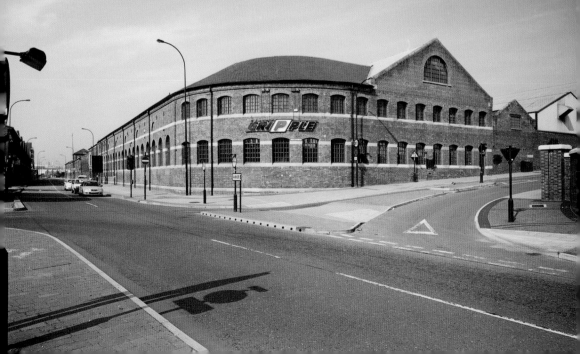

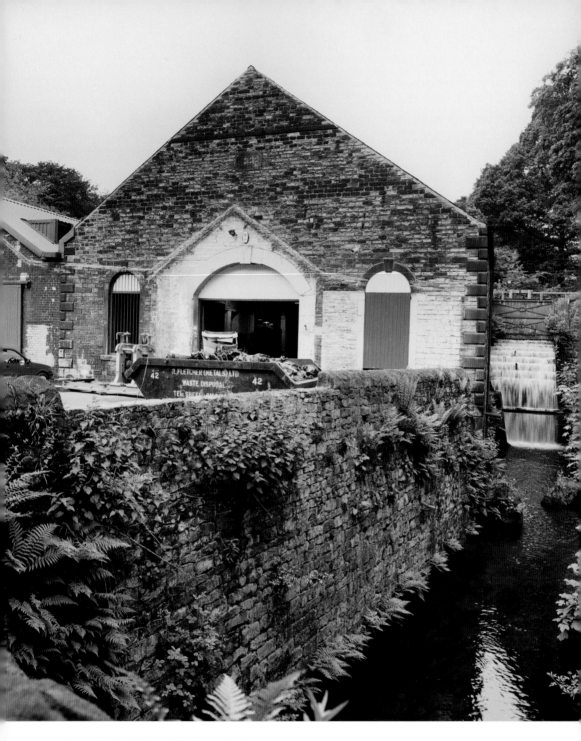

Low Matlock Wheel, Little Matlock
The Low Matlock Wheel is a Grade II*-listed building on the River Loxley to the north-west of Sheffield. Pictured here in 2001, it is now a rolling mill, but started in the eighteenth century as a water-powered cutlers' workshop. By the nineteenth century the site had expanded to include two waterwheels powering tilt and forge hammers.

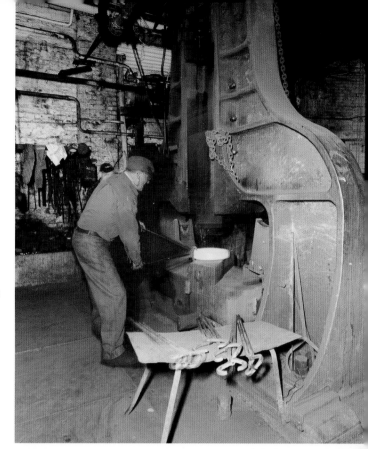

Bath Steelworks
Burkinshaw's Bath Steelworks was situated on Penistone Road. It was originally a corn mill but was converted to steam power in the late nineteenth century. This view, taken in 2001, shows employees working metal using a 30-cwt (hundredweight) hammer in the hand-forging process. Sheffield industry combined manual skills and huge machinery.

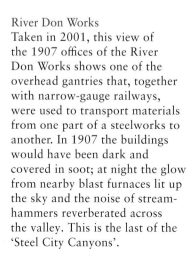

River Don Works
Taken in 2001, this view of the 1907 offices of the River Don Works shows one of the overhead gantries that, together with narrow-gauge railways, were used to transport materials from one part of a steelworks to another. In 1907 the buildings would have been dark and covered in soot; at night the glow from nearby blast furnaces lit up the sky and the noise of stream-hammers reverberated across the valley. This is the last of the 'Steel City Canyons'.

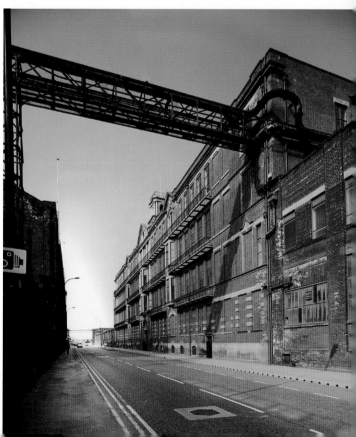

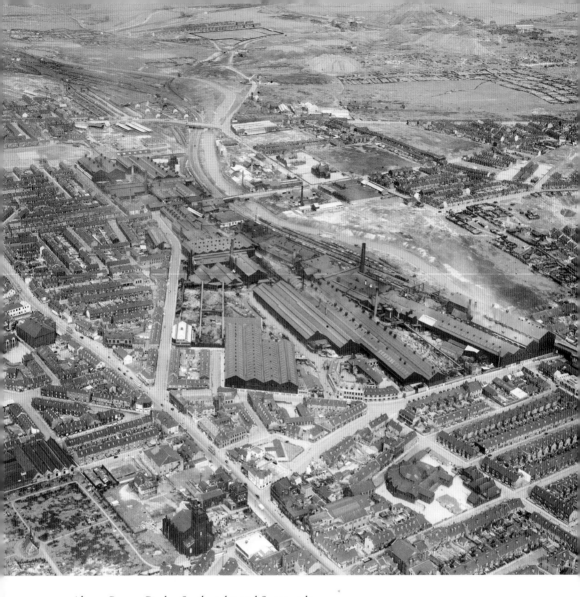

Above: Brown Bayley Steelworks and Surrounds
Pictured in 1947, the Brown Bayley Steelworks on Leeds Road in Attercliffe is shown in the centre of the image. It was founded in 1871 as Brown, Bayley & Dixon and first specialised in making railway tracks. At one time it employed 3,000 people and the works extended over 36 acres. The Don Valley Sports Stadium was later built on the site of the factory. The heavily contaminated material removed from the site seemed to disappear without trace, with rumours of it being landfilled on agricultural land in and around the Peak District National Park. (© Historic England Archive. Aerofilms Collection)

Opposite above: Cammell Laird's Cyclop's Ordnance Steel Tyre and Spring Works
Taken just before the outbreak of the First World War, this view shows workers in the fettling shop at Cammell Laird's Cyclop's Ordnance Steel Tyre and Spring Works. 'Fettling' was the finishing stage of the metalworking process, cleaning and smoothing any rough edges before final inspection. Many words from the industrial processes have lingered on into the local dialect – itself now on the wane. (Reproduced by permission of Historic England Archive)

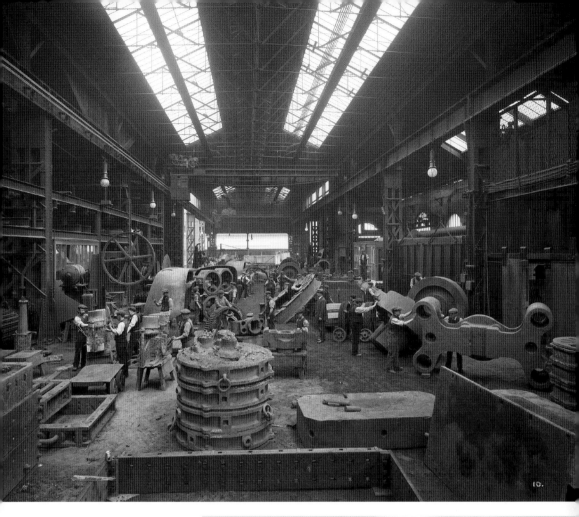

Sharrow Snuff Mills
The Sharrow Snuff Mills, photographed here in 2004 and built in the eighteenth century, are still in existence today. The site was first leased by Thomas Wilson, but the first record of a snuff mill was a few years later in 1763. Thomas's son, Joseph, entered into partnership with Thomas Boulsover, one of the originators of Old Sheffield Plate. Boulsover produced small silver-plated snuffboxes, and Wilson the snuff to put in them. The business developed from there. Snuff is still made on the site today. (© Historic England Archive)

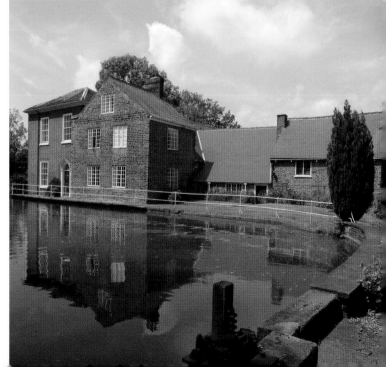

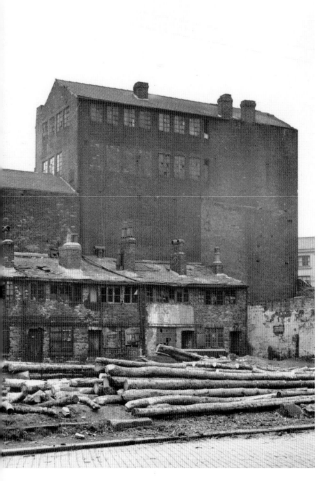
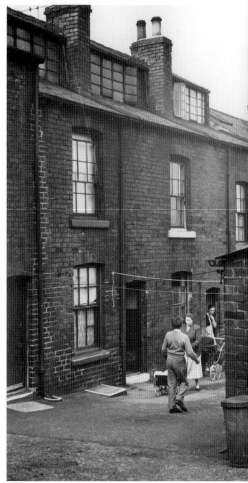

Above left: Little Mesters Factory, St Philip's Road
The Netherthorpe area of Sheffield was once full of little mesters' factories and workshops. Each of the little mesters worked on a self-employed basis, specialising on one part of the process of cutlery, scissors and blade making. This image from 1957 shows one of the factories on St Philips Road just before the area was cleared and redeveloped by Sheffield Corporation for housing. (Reproduced by permission of Historic England Archive)

Above right: Sutton Street
Taken in 1957, this view of Sutton Street, Netherthorpe (near the Brook Hill tower blocks), shows housing built in the nineteenth century with attic workshops. These are linked to the little mesters' tradition of individual families working on 'piecework' at home, a forerunner of the little mesters setting up a factory system. Living conditions were poor and disease was rife. (Reproduced by permission of Historic England Archive)

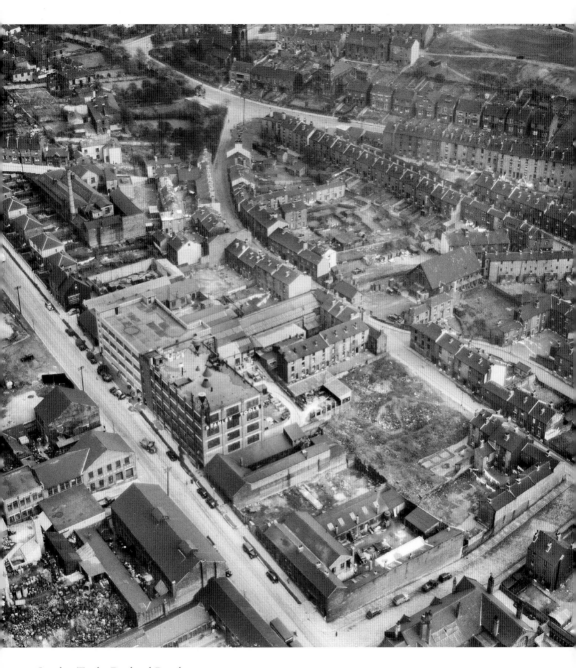

Stanley Tools, Rutland Road
This view looking up Rutland Road, Pitsmoor (in the foreground), was taken in 1950. It shows the offices and one of the factories that were owned by Stanley Works (GB) Ltd, later Stanley Tools Ltd. Stanley Works was an American company that came to Sheffield in the mid-1930s, buying J. A. Chapman Ltd, a manufacturer of joiners' braces, planes and drills etc. This was the foundation for the extensive range of tools that the company became famous for. (© Historic England Archive. Aerofilms Collection)

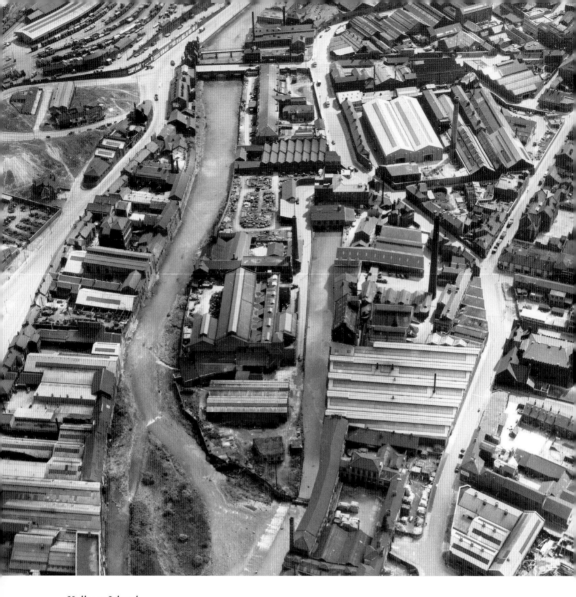

Kelham Island

Kelham Island was home to a number of typical metal trades enterprises, including the Union Wheel, adjacent to the Corporation Street Bridge over the River Don, at the top of the image; below it, W. A. Tyzack's Horsman Works; then Samuel Staniforth's Smithfields Works; and at the end of the island Russell and Kelham Iron Works, of which only the eastern range survives. This building is part of the Kelham Island Industrial Museum, which mainly occupies the former Sheffield Corporation Electric Power Station (which supplied the city's tram system) complex at the southern end of the island. It is one of the first industrial museums in the world. The main channel of the River Don is to the left, with a weir and goit (channel) running towards the Britannia flour mill on the right. Henry Hoole's Green Works is immediately to the right of the sluice gate and the head of the Goit. In 1951, the area – still heavily industrial, as seen here – included the world-famous James Dixon Place fronting on Green Lane, which is further west and below the picture. (© Historic England Archive. Aerofilms Collection)

Shops, Markets and Commerce

Sheffield's markets charter was granted in 1296. It permitted the lord of the manor to hold weekly markets and an annual fair. The first markets grew up around the Castlegate area and this association continued into the twenty-first century when the market was moved to the bottom of the Moor. Unlike many cities, Sheffield does not have one defined shopping and commercial area within its centre. This has partly arisen from the 'village' feel of Sheffield, but also reflects competition from Meadowhall and other out-of-town retail outlets. Recent regeneration has brought new hotels into the city, some as replacements for the older luxury hotels that were once a feature of Sheffield life.

Waingate and Haymarket
This view of the Waingate and Haymarket beyond shows part of the site of Sheffield Castle and Sheffield Town Hall in the middle right. The old Shambles (abattoir area) was located in the lighter range in the lower part of the image and the cleared area just above it is where Castle Market would be built. Fitzalan Market Hall, the later location of the Shambles, which was soon to be demolished, can be seen to the top right with Fitzalan Square just beyond. This is an area that was transformed as it was badly affected during the Blitz, and is undergoing another round of transformation due to the relocation of the Markets to the Moor. (© Historic England Archive. Aerofilms Collection)

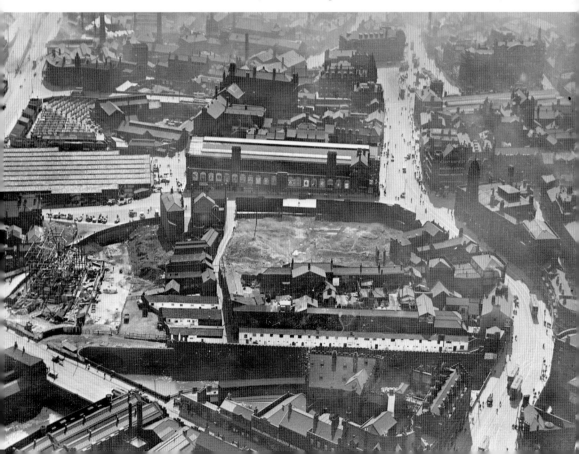

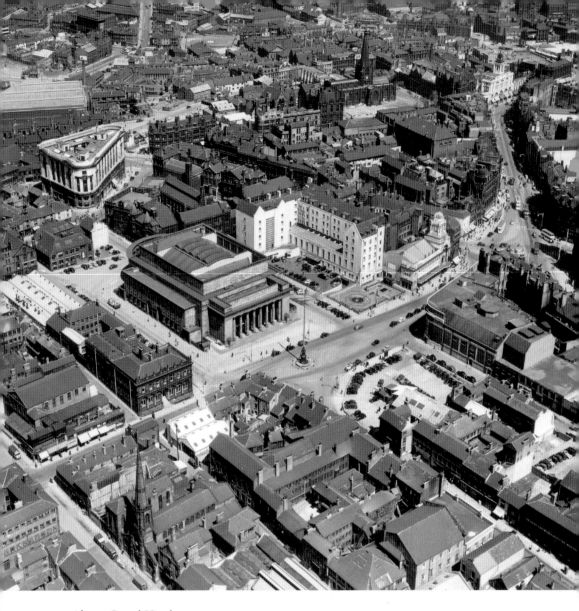

Above: Grand Hotel
The large imposing white building in the centre of this image from 1951, next to the City Hall and Barker's Pool, is the former Grand Hotel. Built in 1910, the hotel, with its main entrance on Leopold Street, had 300 rooms. It was demolished in 1973 but in its heyday it was Sheffield's most prestigious hotel and used by celebrities when they came to perform in the city and the nearby venues. (© Historic England Archive. Aerofilms Collection)

Opposite above: The Corn Exchange
The Corn Exchange on Sheaf Street, shown here around 1910–20, was built for the Duke of Norfolk in 1881. At the time the duke still held all the market rights for the town and so had a financial interest in promoting such trade venues. The building was demolished in 1964, although the central hall had been gutted by fire in 1947. The various markets were hugely important in the local economy with echoes back to medieval times. (Reproduced by permission of Historic England Archive)

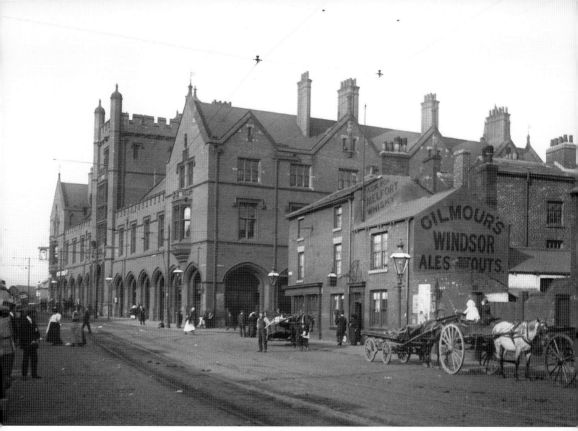

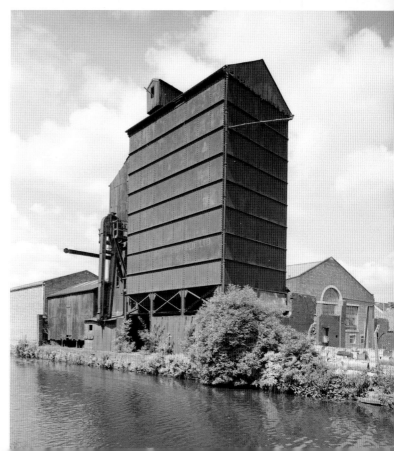

Grain Elevator
Taken in 1989, this image shows a grain silo and elevator alongside the Sheffield and Tinsley Canal at Canal Street. It was built in 1920 and has a steel frame with iron panel cladding – components that were no doubt produced locally. The closure of buildings like this and the general refurbishment of the canal area caused deep-seated concerns among the boating community at the time. (© Crown copyright. Historic England Archive)

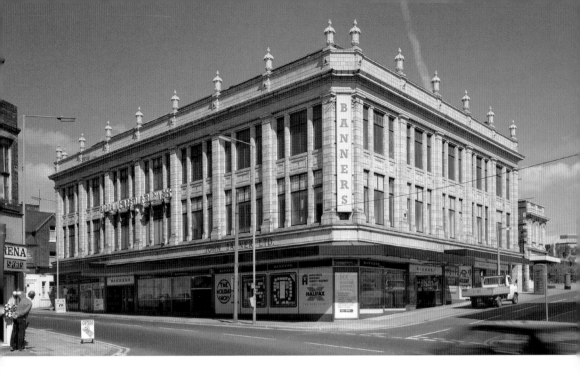

Above: John Banners Department Store

The imposing white building of John Banners Department Store (built in 1934) replaced an earlier shop on the site. Closed as a department store in 1980, it split into different business units. This picture from 1989 shows the ornate upper floors. Banners was one of the first department stores to install escalators between floors. Before hire purchase and credit arrangements, Banners accepted loan cheques, which people bought from money lenders. The store also issued its own 'money' in the form of Banners tokens, which could only be spent in the store. They were given to customers rather than giving change on the loan cheques. The system helped many families to make larger purchases than would otherwise have been possible. (© Crown copyright. Historic England Archive)

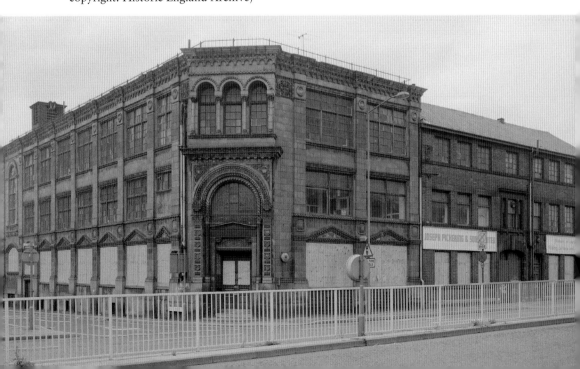

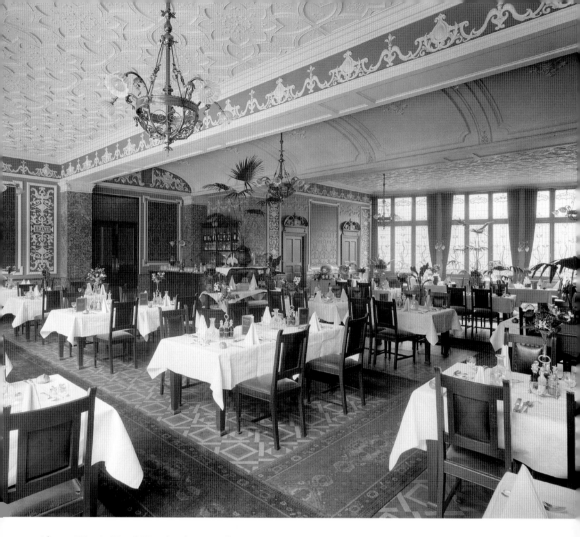

Above: King's Head Hotel, Change Alley
Taken in 1902, the image shows one of the ornate public rooms at the King's Head Hotel in Change Alley. Change Alley ran from High Street to Norfolk Street until the 1960s redevelopment of the city centre. However, the hotel had already been demolished by then. This view of the restaurant gives an idea of the spacious and luxurious feel to the hotel. The King's Head Hotel originated in the eighteenth century but was rebuilt and extended in the nineteenth century. One famous guest was Charles Dickens, who stayed there in 1858 on one of his lecture tours. (Reproduced by permission of Historic England Archive)

Opposite below: Pickering Buildings, No. 57 Moore Street
Built in 1908, the Pickering Works at No. 57 Moore Street specialised in making decorative tins, wooden and cardboard boxes for the local cutlery and luxury goods trades. Each box was assembled and finished by hand and many women worked there. The ornate terracotta façade, pictured here in 1991, was saved when the rest of the building was demolished in 1988. (© Crown copyright. Historic England Archive)

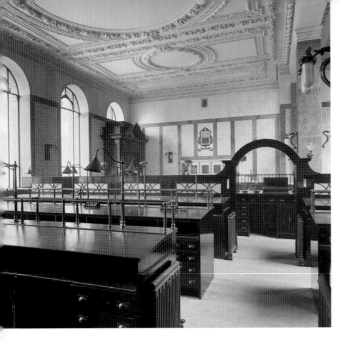

York City and County Bank, Nos 1–3 Market Place
Now familiar to many as the Bankers Draft public house, this building started life as the York City and County Bank. The address of this still-imposing building is Nos 1–3 Market Place – the corner of High Street and Angel Street. This interior view, taken in 1904, shows the banking hall with its polished wooden desks and ornate ceiling. For many years through the twentieth century it was a branch of the Midland Bank (now HSBC). (Reproduced by permission of Historic England Archive)

First-floor Depot at Sheffield City Goods Station, Broad Street
This interior view, taken in 1927, is of one of the many warehouses and depots at Sheffield City Goods Station on Broad Street. It shows merchandise stored in George Bassett & Co.'s first-floor depot at a time when most freight was transported by rail. Raw materials would be brought in and finished products, such as Liquorice Allsorts, were stored before being transferred to railway trucks to continue their journey. (Reproduced by permission of Historic England Archive)

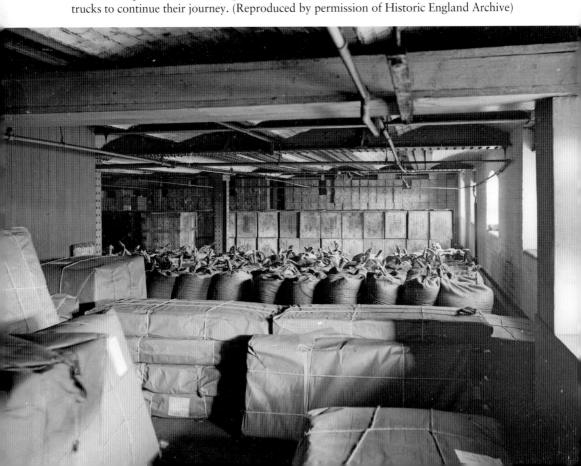

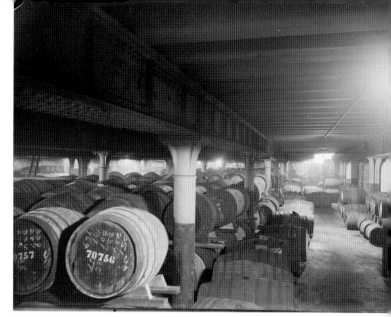

Wicker Goods Station
Taken in 1922, these rows of barrels are in a bonded warehouse near to the Wicker Goods Station. Bonded warehouses stored goods that had excise duty paid on them and it is believed that the barrels shown here contained alcohol from Wiley & Co. Ltd. This is another example of a commonplace commercial practice long-since forgotten. (Reproduced by permission of Historic England Archive)

Sheffield City Goods Station, Broad Street
Another of the many warehouse spaces at Sheffield City Goods Station. This is the depot of the Associated Biscuit Manufacturers Ltd. This was a time when most goods and provisions were moved by rail and large storage facilities were needed close to the railway depot. The image here from 1927 shows men stacking boxes of biscuits prior to them being loaded onto delivery vans for distribution around the city. (Reproduced by permission of Historic England Archive)

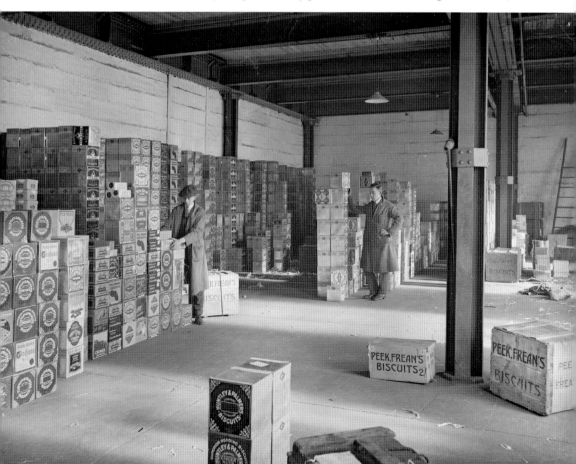

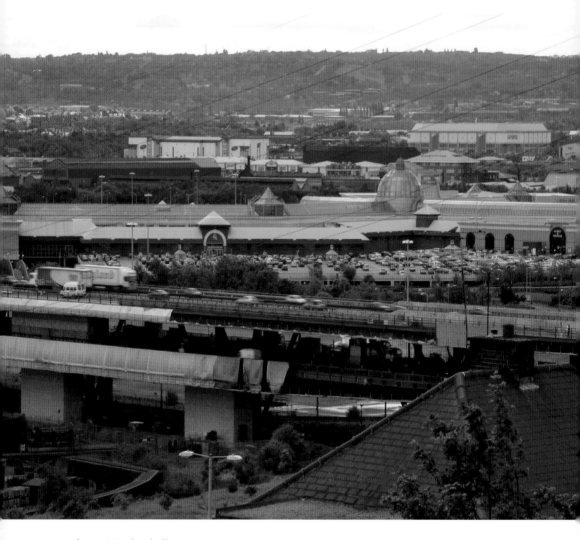

Above: Meadowhall
Taken in 2004 from the hill above Tinsley and Meadowhall, this general view shows the extent of the indoor shopping centre, which has approximately 280 shops. It was built on the outskirts of Sheffield and Rotherham on the site of Hadfields' East Hecla Steelworks and opened in September 1990. At that time it was the second largest American-style shopping centre in the UK. It is now the eighth largest, although it is still the biggest in Yorkshire. (© Historic England Archive)

Opposite above: Market Hall
The Castle Market on Exchange Street opened in 1959 to house traders from the close by old Norfolk Market Hall. It also included office accommodation and shops fronting the road; it was extended in 1964. This interior view of the market hall was taken just before the building was closed and the market moved to the Moor. The move ended over 700 years of a market being held near to the castle area. This view shows the functional but spacious nature of the building, which accommodated clothes, general retail, fresh food and takeaway food units. (© Historic England Archive)

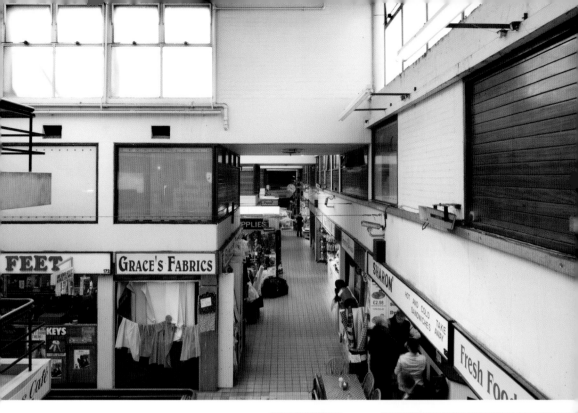

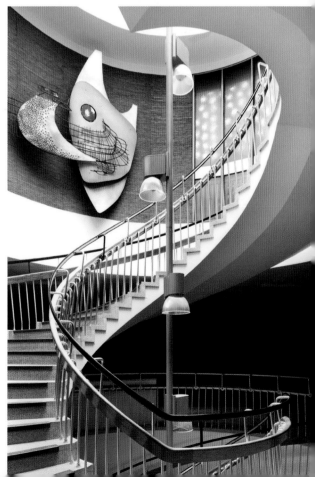

Cantilevered Stairway of a Former Department Store

The Brightside and Carbrook Co-op Department Store on Angel Street in the centre of Sheffield was built to replace an earlier store destroyed in the Blitz. It has now closed as a department store, although there is still a food shop on the ground floor. This interior view, taken in 2011, shows the iconic cantilevered stairway and artwork that was a feature of the store. (© Historic England Archive)

John Lewis
Opened in the early 1960s by Cole Brothers Ltd, this department store is now part of the
John Lewis chain. The view from 2011 looking down Cambridge Street shows the ceramic
tiles on the upper floors, which gives it a distinctive look. The new store was built by Cole
Brothers Ltd as part of the redevelopment of Sheffield and to give the shop bigger premises.
They had moved from their old location, which opened in 1847 as a hosiery shop at the bottom
of Fargate (No. 4 Fargate), affectionately known by generations as 'Coles Corner'. The new
building was built opposite the City Hall on a derelict site. It was previously a theatre known as
the Albert Hall, which had been gutted by fire in 1937. (© Historic England Archive)

Right: Fat Cat, Alma Street
The Fat Cat public house on Alma Street, in the Kelham Island district, is pictured here in 2016. It was built in the nineteenth century and first known as The Alma. It was bought in 1981 by Dave Wickett and Bruce Bentley to promote small brewers and real ales. In 1990, Dave Wickett opened his own brewery in the beer garden and the Kelham Island Brewery was born. Today it is a thriving pub with a range of beers and good food, a pioneer of the redevelopment of the area. (© Historic England Archive)

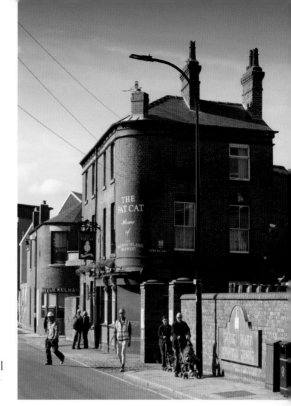

Below: Woolworth's, Nos 12–14 Haymarket
Taken in the 1920s, this is an exterior view of the front of the F. W. Woolworth's shop at Nos 12–14 Haymarket. The plainer ground-floor frontage is at odds with the more ornate first floor. After the Second World War and the redevelopment of the Haymarket area, Woolworth's moved into a much larger store on Haymarket. The building still exists and is now the Wilko store. (Reproduced by permission of Historic England Archive)

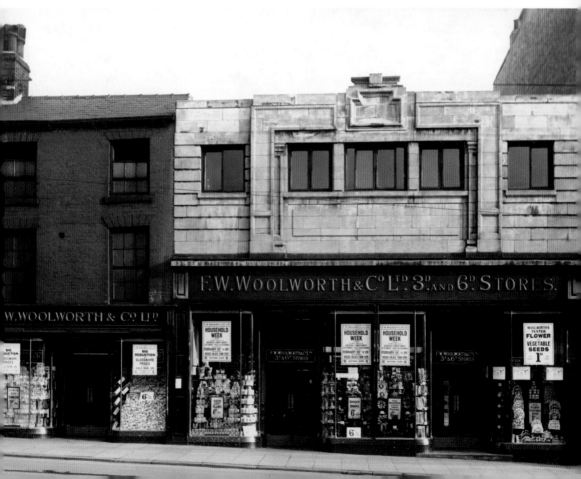

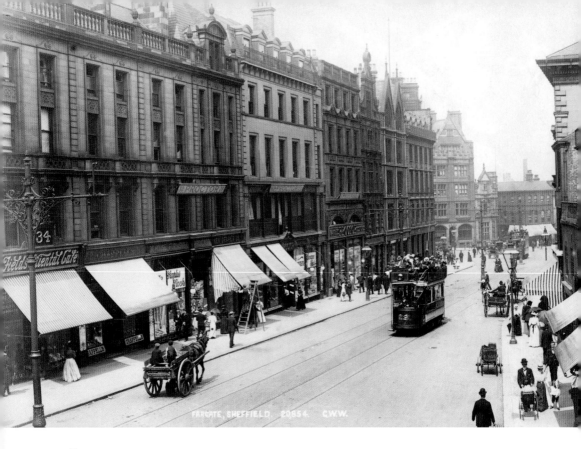

Fargate

This view dating from around 1900 looks north along Fargate – long before pedestrianisation of the area. Fields Oriental Café is on the left at No. 34 Fargate. Note the awnings in front of the shops and an electric tram in the centre. The trams ran in Sheffield until the 1960s with a hiatus until the 1990s Supertram. (Reproduced by permission of Historic England Archive)

Trustee Savings Bank, No. 570 Attercliffe Road

Pictured here in 1989, this ornate façade of the Trustee Savings Bank on Attercliffe Road in Sheffield was Grade II listed in 1995. The frontage is typical of the design of the Trustee Savings Banks. These banks were set up in the nineteenth century specifically for small and medium investors, craftsmen etc. who didn't have sufficient resources to access the larger banks. At this time Attercliffe was a thriving residential and commercial area beyond the city centre. (© Crown copyright. Historic England Archive)

Transport, Energy and Infrastructure

The rapid expansion of Sheffield from the early nineteenth century onwards was driven by heavy industry. In particular, coal mining and the iron and steelworks not only made use of the railways and steam, gas and electric power, but also provided the raw materials and products used. Later in the nineteenth century the growth also resulted in the beginnings of public health provision and power for residential areas that was first provided by local councils and private companies. Education and recreation also emerged from the gloom of the Industrial Revolution.

Low Matlock Wheel
One of the few remaining examples of a working waterwheel. This image from 2001 is of the Low Matlock Wheel in the Loxley Valley to the north of Sheffield. Water-powered mill sites were once abundant along the main rivers and smaller stream valleys across the Sheffield area. They powered the forges and workshops for metal manufacture and tool making from medieval times until well into the nineteenth century. However, a few, such as the example, here continued to operate into the twentieth century, supplementing their power needs that by then were mostly coal-generated. The mill sites could be quite small, concentrating on one operation, or might develop into large-scale industrial complexes, such as at Abbeydale Industrial Hamlet.

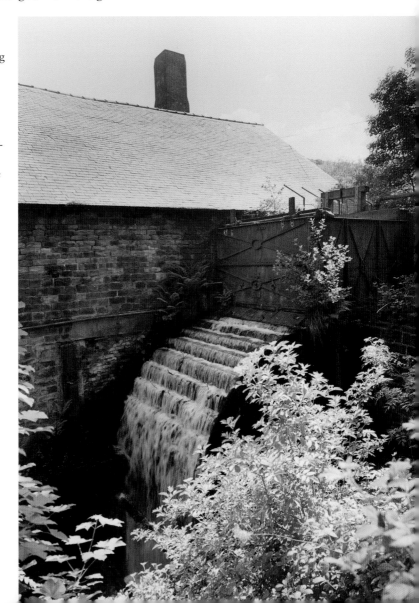

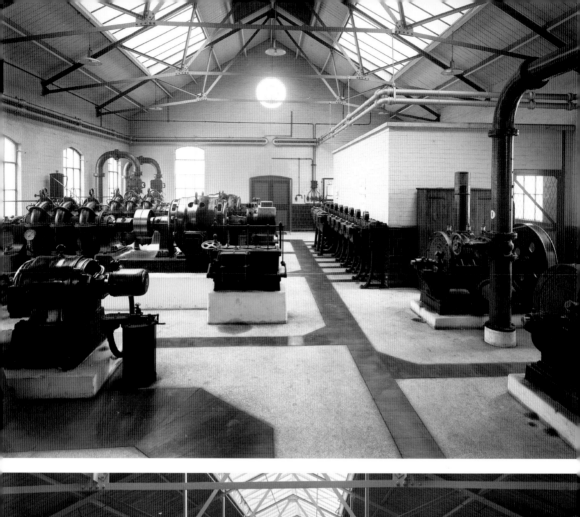

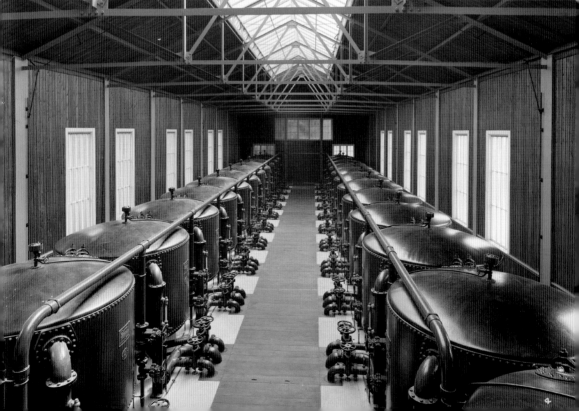

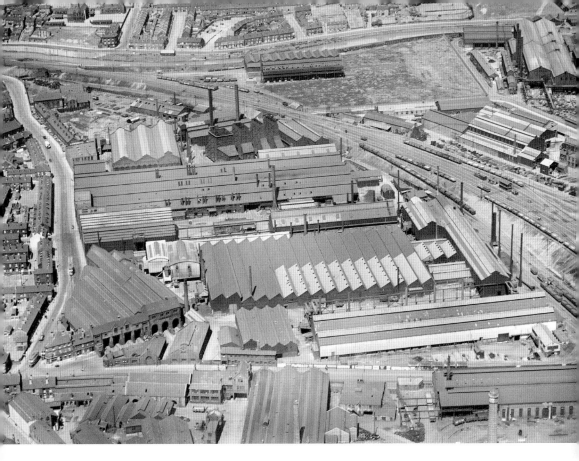

Above: Staybrite Steelworks and Corporation Tram Depot
This view of Sheffield Corporation's Tram Depot at Tinsley with adjacent steelworks and other infrastructure was taken in 1933. It was built in 1874, initially for horse-drawn trams, by the Sheffield Tramways Company. The company was taken over by Sheffield Corporation and the depot converted to house electric trams with a capacity of ninety-five. The Tinsley to Nether Edge electric tram service – Sheffield's first – opened in 1899. Rotherham Corporation extended their tram network to link to the Tinsley line in 1905, so directly connecting the two towns. This arrangement ended at the beginning of the First World War. (© Historic England Archive. Aerofilms Collection)

Opposite above: Pump House at the Blackburn Meadows Sewage Works
This is an interior view of the pump house at the Blackburn Meadows sewage works, taken in 1923. Note the light airy space and the ordered rows of machinery. The image would have been taken at a time when the 'Sheffield System' of sewage treatment was being promoted with visits made by other local authorities interested in improving the water quality of the treated effluent. (Reproduced by permission of Historic England Archive)

Opposite below: Water Filtration Works, Mill Lea Road
Reservoirs were built during the nineteenth and early twentieth centuries to supply clean water to the residents of Sheffield. Associated with the reservoirs were the filtration works, which, through chemical processes, made the water fit to drink. In some cases they also took out the brown tinge to the water that came from the peat moorlands. This 1923 view is of the rows of filters at the water filtration works in Low Bradfield, which managed the water from Agden, Dale Dike and Strines reservoirs. It opened in 1913 and closed in the 1990s when a more modern treatment works was built lower down the Loxley Valley. (Reproduced by permission of Historic England Archive)

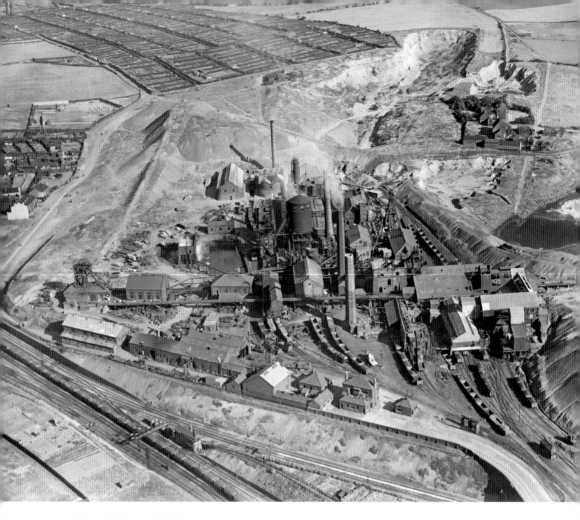

Above: Nunnery Colliery

The Nunnery Colliery (coal mine) was located close to Sheffield city centre, near to Woodbourn Road. Its name lives on as Nunnery Square and one of the Sheffield Supertram Park and Ride locations. This aerial panorama, taken in 1935, shows the extent of the colliery buildings and spoil heaps. In the foreground the railway wagons lined up to take the coal away. The mine opened in 1868 and closed for coal production in 1953, although pumping operations continued until the 1980s. (© Historic England Archive. Aerofilms Collection)

Opposite above: Industrial Buildings Lining Sheffield Canal

This is a typical view from the late 1950s of old industrial buildings and factory chimneys with the Sheffield and Tinsley Canal running through its centre. The canal was built in the early nineteenth century to provide a navigable waterway into the centre of Sheffield. Prior to that freight and industrial goods had to be transported by cart into and out of Sheffield. But by this time the coal industry was developing and the canal provided a means of transporting the coal onto the wider waterways network. The canal is still in use today, but now mostly for leisure with regular boat trips along the canal. (Reproduced by permission of Historic England Archive)

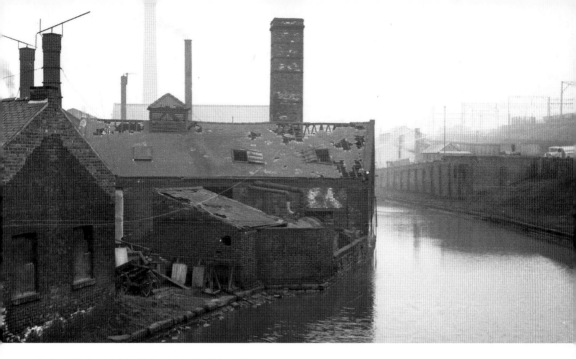

Below: Industrial Buildings by the River Don

It is difficult to imagine today the extent of the railway goods depots that grew up around the Nursery Street and Wicker areas of the city in the nineteenth century. This was the hub for goods and raw materials of all types to move in and out of Sheffield. The pre-eminence of rail freight to move all types of goods continued well into the twentieth century, as this view from 1957 of the British Railways Goods Depot at Bridgehouses shows. Today this view has changed and a new road – Derek Dooley Way – has been built through what was the depot. However, the old footbridge, known locally as Ironbridge, in the foreground spanning the River Don still exists. It replaced the bridge that formed the second river crossing of the Don (after Lady's Bridge), which was washed away in the Sheffield flood of 1864. It can be seen from the traffic lights at the junction with Corporation Street, although it is currently not in use as a river crossing. (Reproduced by permission of Historic England Archive)

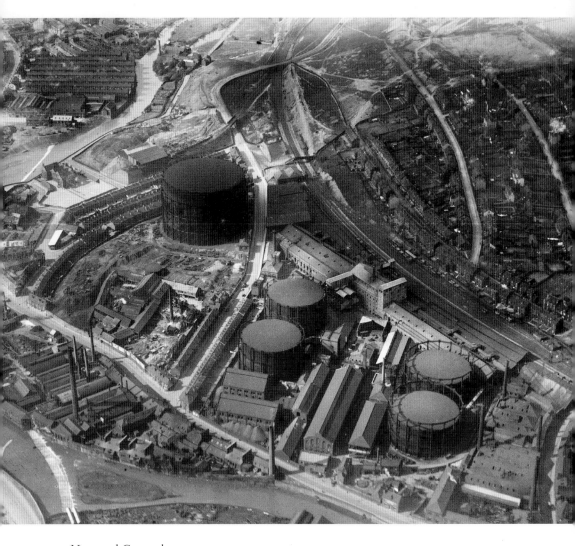

Neepsend Gasworks
Neepsend Gasworks was opened in the 1850s by the Gas Consumers Company, which later merged with the Sheffield United Gas Light Company whose headquarters building is on Commercial Street (known as Canada House). The Neepsend Gasworks served the industrial area along this part of the Don Valley and around the Kelham Island area. The four large gasometers that stored the town's gas can be seen in the picture – this was manufactured from coal. During the fuel shortages in the 1940s and 1950s, coke from the gasworks was sold to local people as an alternative to coal. People had to collect it themselves from the gasworks using wheelbarrows and handcarts. (© Historic England Archive. Aerofilms Collection)

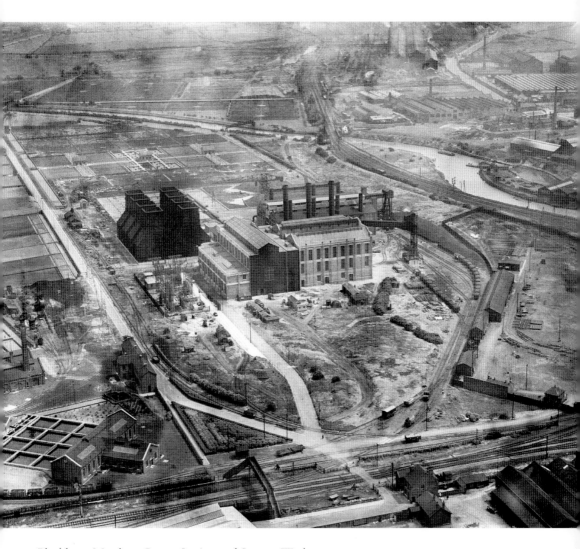

Blackburn Meadows Power Station and Sewage Works
Blackburn Meadows on the outskirts of Sheffield was chosen as the site for Sheffield's main
sewage works as it was downstream and on low-lying ground. It opened in 1884 and is still in
operation today. The first rudimentary sewage cleaning system was improved here with early
use of bio-aeration tanks and the development of the innovative 'Sheffield system'. A coal-fired
electric power station was built adjacent to the sewage works by Sheffield Corporation in 1921.
It was built to serve the heavy industry along the Lower Don Valley. Taken in 1932, this view
shows the power station buildings in the centre, long before the Tinsley Towers and the M1
were built. (© Historic England Archive. Aerofilms Collection)

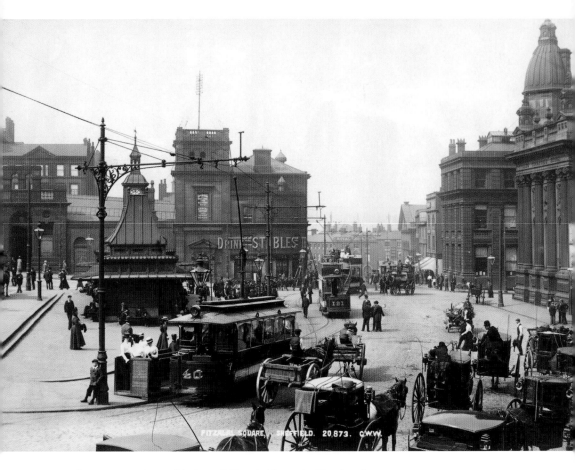

Above: Horse-drawn Taxis and Electric Trams in Fitzalan Square
Taken around the turn of the twentieth century, Fitzalan Square was pictured busy with electric trams and horse-drawn taxis. The image shows the old and new forms of transport that ran side by side at the beginning of the twentieth century. At the time the first electric tram routes between the industrial east end and the suburbs were being developed, but horsepower was still a key form of transport. (Reproduced by permission of Historic England Archive)

Opposite below: Sheffield Midland Station
This station was built for the Midland Railway and opened in 1870 – the last of the main railway stations in Sheffield. It is now the principal rail station for the city after the Victoria station, next to the Wicker Arches, closed in 1970. This view shows the central part of the Midland station, with the old walkway and roof held up on slender pillars. The station was expanded to take the extra passenger transport from Victoria station and has been modernised since then. One newer feature is the refurbishment of what was once the first-class passenger lounge on Platform 1 to the Sheffield Tap, a real ale pub and microbrewery. The original buildings and façades are now listed structures. (Reproduced by permission of Historic England Archive)

Newbegin Colliery
This image was taken in 1938 at the already closed 'Newbegin' or Newbiggin Colliery at Tankersley on the outskirts of Sheffield. It shows an inverted Cornish beam engine that would have been used for pumping water from the colliery. The Cornish beam engines were developed by Newcomen and others in the eighteenth century. They were fixed steam engines that revolutionised the mining industry as they enabled large quantities of water to be pumped out of the mines, allowing deep-mining operations to continue. (Reproduced by permission of Historic England Archive)

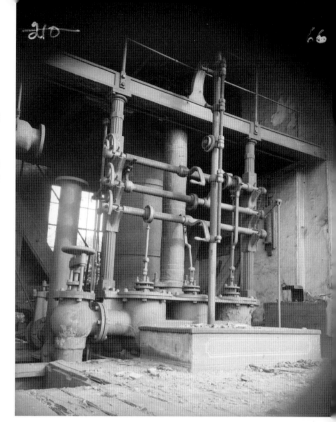

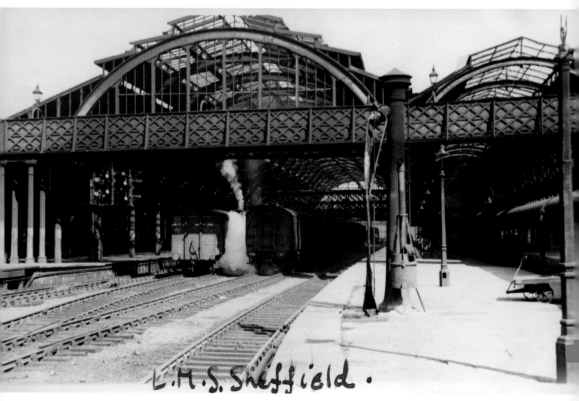

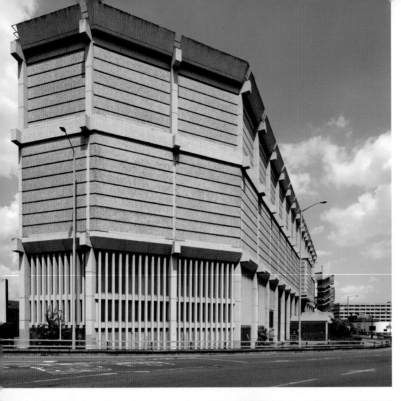

Electricity Substation, Moore Street
This modern concrete structure on Moore Street in the centre of Sheffield houses an electricity substation. It was designed by Jefferson Sheard in 1968. The simple lines and stark nature of the building is an example of brutalist architecture. It was made a Grade II-listed building in 2013 and was photographed here in 2014. (© Historic England Archive)

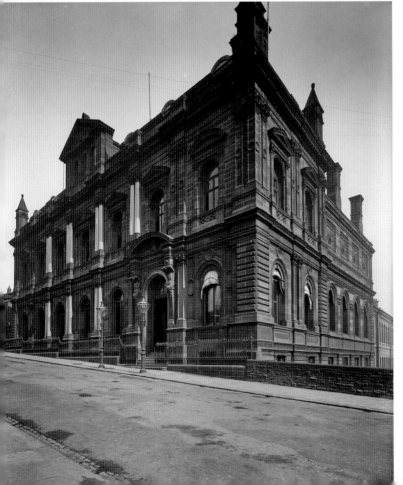

Sheffield United Gas Light Company
The grand headquarters of the Sheffield United Gas Light Company were built in the Italianate style in 1874, with Hadfield & Son as the architects. The building continued as the gas board offices until 1972. The view here from Commercial Street shows a very grimy building in 1897. Today the Supertram route runs in front of the building. At the back of the main building on Shude Hill were the canteen, workshop and depot for the gas board employees – far less ornate than the front. (Reproduced by permission of Historic England Archive)

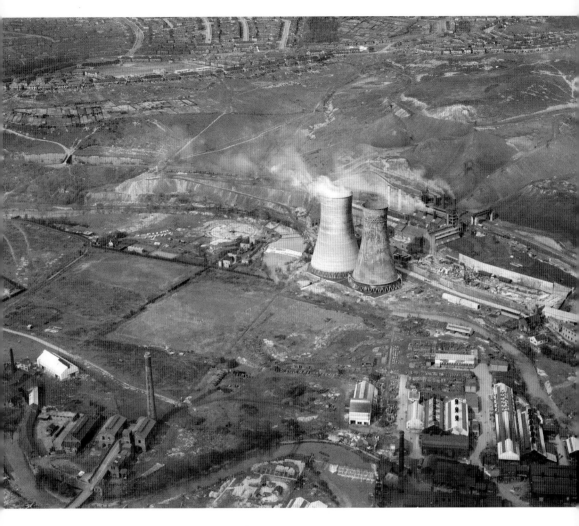

Sheffield Corporation Power Station, Owlerton
Taken in the late 1940s, this view of Sheffield Corporation's Electricity Generating Power
Station shows the two large cooling towers added in 1937 and 1947 respectively. The power
station at Owlerton (sometimes known as the Neepsend Power Station) was built in 1902 next
to the River Don – a good water supply and with a railway line for bringing in coal. Water was
discharged into the river and local children used to swim just downstream as the water was
warm. The power station closed in 1976 but the site is still operational. (© Historic England
Archive. Aerofilms Collection)

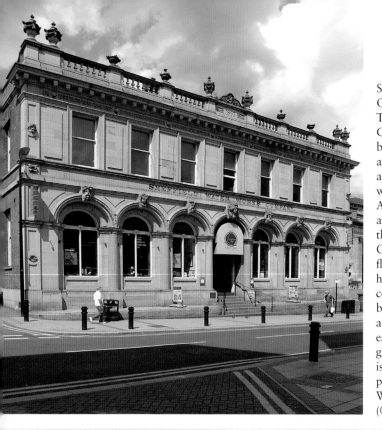

Sheffield Water Works Company Offices, Division Street
The Sheffield Water Works Company headquarters were built at Nos 2–12 Division Street and opened in 1867. It is now a Grade II-listed building and was designed by Flockton & Abbot. As well as the date stone at the top of the building and the name 'Sheffield Water Works Company' carved above the first floor, the building's origins as the headquarters of Sheffield's water company are commemorated by the carved heads of Roman and Greek water gods above each of the windows on the ground floor. The building is now a JD Wetherspoon's pub called The Sheffield Waterworks Company.
(© Historic England Archive)

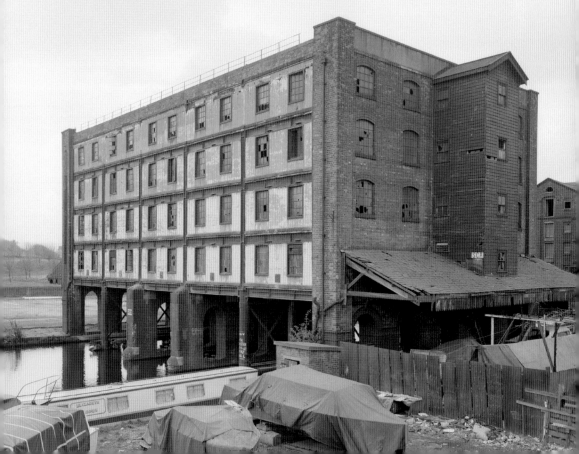

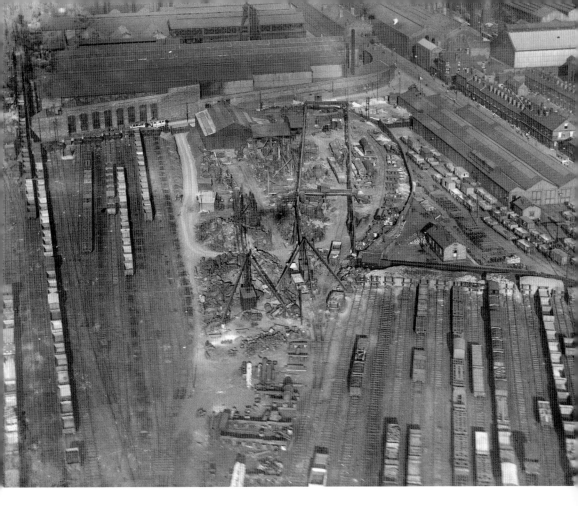

Above: Brightside Railway Sidings
Pictured in 1921, this aerial view of the railway sidings at Brightside shows the extent of the freight traffic, with many lines and long rows of wagons visible. This was one of the vital hubs for the heavy industry along the Don Valley to receive raw materials and then send on their finished products through the rail network. Many of the larger firms had their own internal rail lines linked to the main network, which eased the passage of goods to and fro. Industries like coal mining also had extensive networks of rail connections. (© Historic England Archive. Aerofilms Collection)

Opposite below: Straddle Warehouse
The Sheffield and Tinsley Canal was built by the Sheffield Canal Company and opened in 1819. It created a navigable waterway from the River Don at Tinsley right into the heart of the then town at a time when heavy industry and coal mining was beginning to expand. Its heyday was short-lived because of the railways, but it continued to carry freight well into the twentieth century. This view, taken in 1989, shows the Straddle Warehouse in a semi-derelict state. The warehouse had been built in the 1890s across the basin at Victoria Quays. The whole area has now been refurbished and the warehouse turned into office accommodation, complete with external multicoloured lights in winter. (© Crown copyright. Historic England Archive)

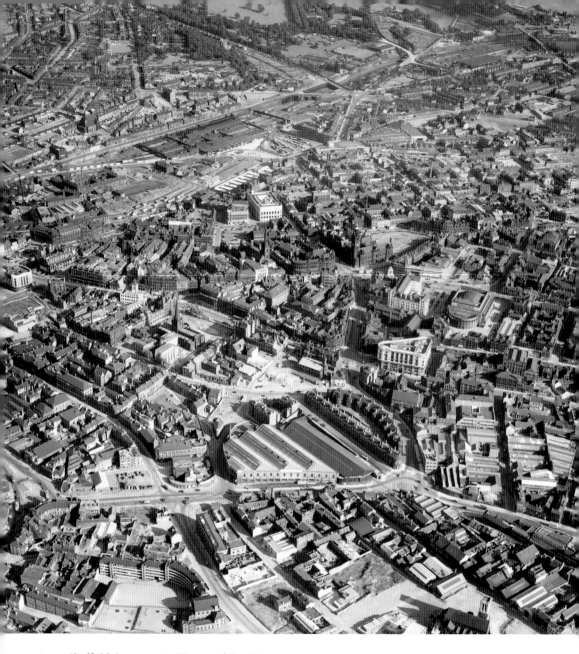

Sheffield Corporation Tram and Bus Depot

Sheffield Corporation's Tenter Street Tram and Bus Depot is shown in the lower middle of the picture. This was one of several depots around the city, and one of two in the centre – the other being the Shoreham Street or Leadmill Tram and Bus Depot, which remained operational for buses until the 1990s. The Tenter Street Depot was opened in 1928 with access for trams from the junction of Silver Street Head. It closed in 1960 after the last Sheffield tram had made its journey; however, motor buses continued to use the upper level accessed from Hawley Street until the late 1960s. (© Historic England Archive. Aerofilms Collection)

Suburbs, Housing and Landscape

The boundaries of the city of Sheffield expanded rapidly in the twentieth century, incorporating many of the outlying districts and historic settlements that ranged among the hills and valleys. The expansion also enabled the city to build more housing to accommodate a growing population and replace obsolete houses. Many historic and much older properties were swept away in the name of progress, but there are still a few examples hidden away in the modern suburbs.

Manor Estate under Construction
Taken in the late 1920s, this image shows the concentric circle road layout of the new Manor local authority housing estate, with the Prince of Wales dual carriageway running as an 'S' shape through the middle. The Manor estate was built to high standards with indoor bathrooms and large gardens to house well-paid workers. Interestingly, some of the bricks were recycled from the former aircraft repair depot at Meadowhead and the mortar was partly made from industrial by-products. Sixty years later, this mortar had corroded the wall-ties of the houses and many had to be demolished. A new housing estate has now been built over much of the area that is shown in the picture. (© Historic England Archive. Aerofilms Collection)

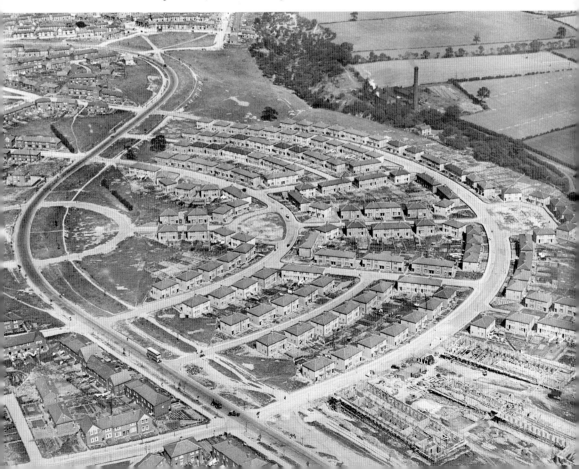

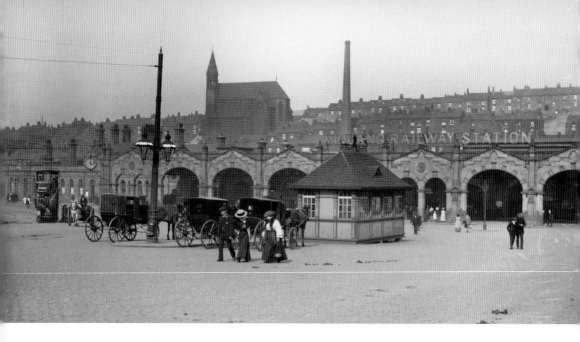

Above: Park Hill

This photograph from the early 1900s shows St John's Church dominating the skyline of the old suburb of Park Hill on the hillside above the Midland railway station. In this picture, taken at the beginning of the twentieth century, the church and railway station remain but most of the old courts and tenement housing were cleared in the 1950s to make way for a new modern housing complex. (Reproduced by permission of Historic England Archive)

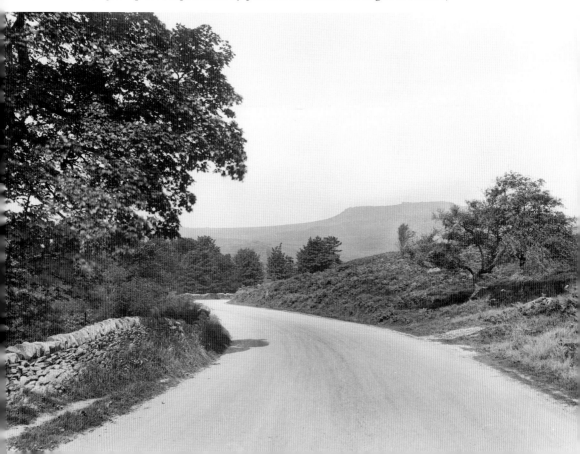

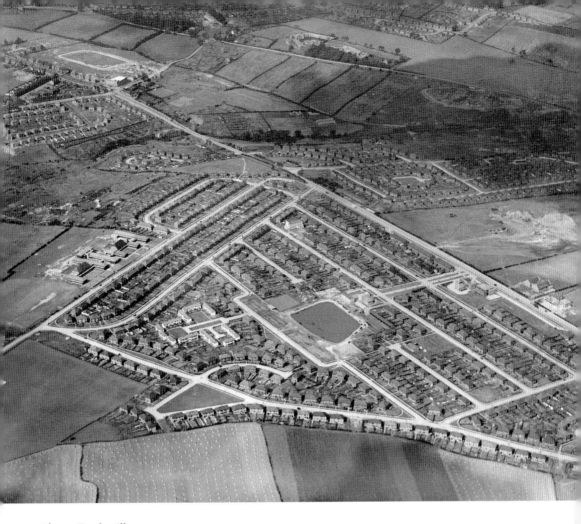

Above: Frecheville

The Frecheville estate, seen here in 1939, was built by the private housebuilding firm of Henry Boot. At the time the area was in Derbyshire, although now it is a suburb of Sheffield. It was built on farmland that had once been part of the ancient Birley Moor. The large pond in the centre of the picture is part of the older landscape but was taken over as a fishing pond by the local residents. A community centre, schools and shops were built as part of the estate. (© Historic England Archive. Aerofilms Collection)

Opposite below: Hathersage Moor

Taken in 1893, this view shows the road on Hathersage Moor, running between Hathersage Booths and Upper Burbage Bridge, with Higger Tor and Carl Wark dominating the view. At the time of the photograph this area of moorland was well outside the Sheffield boundary, but by the 1930s outlying districts such as Dore and Totley had been incorporated into Sheffield. With support from the fledgling council for the Protection of Rural England, and the takeover of the Longshaw estate by the National Trust, the land came into Sheffield but was protected from development. After the Second World War, with the creation of the Peak District National Park, Sheffield became the only city to have part of a national park within its boundary. (Reproduced by permission of Historic England Archive)

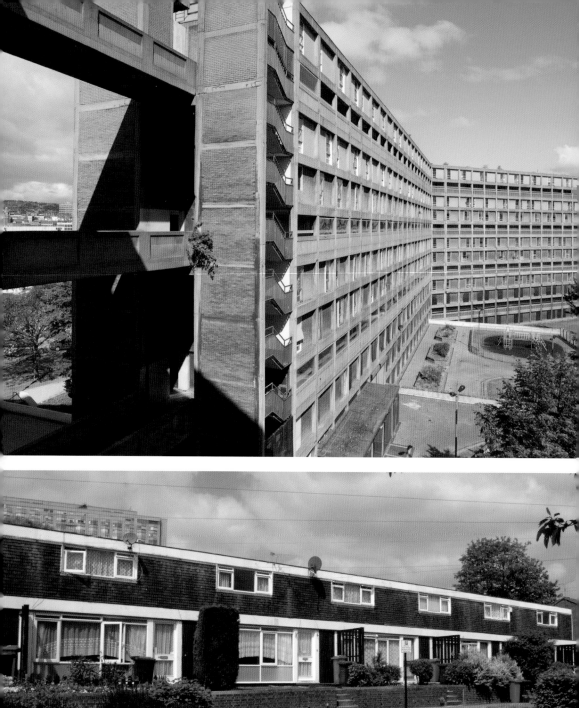

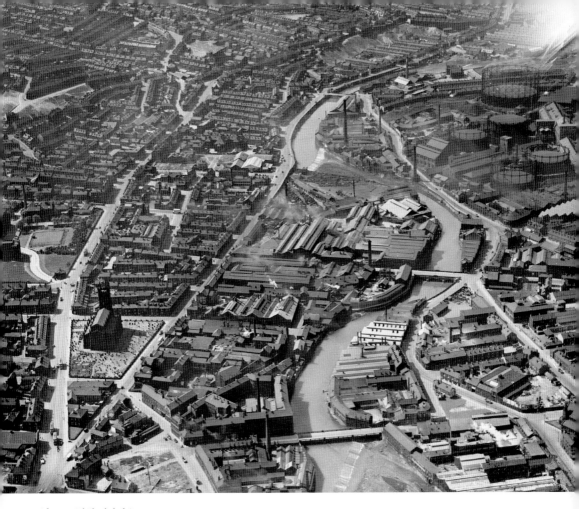

Above: Philadelphia

Taken in 1939, this photograph shows the old nineteenth-century pattern of terraced housing in the Philadelphia area of central Sheffield. Only a year later many of these houses had been damaged and destroyed in the Blitz. James Dixon's world-famous Cornish Place can be seen in the foreground, to the left of Ball Street Bridge. St Philip's Church, in the bottom left of the image, served the local community and was also damaged in 1940. It was demolished in the 1960s. Most of the older housing that remained was cleared under slum-clearance programmes in the late 1950s and early 1960s. Many people from this area were moved to the Gleadless Valley estate and new housing built on the cleared sites. (© Historic England Archive. Aerofilms Collection)

Opposite above: Park Hill

This view of part of the Park Hill flats complex, built in the early 1960s, shows the long corridors or 'streets in the sky' that was a particular feature of the development. The 'streets' were named after the old courts that formerly occupied the site. In total, there were 959 properties in blocks ranging from four to thirteen storeys high. The complex became a listed building in 2006 as it is one of the few examples of this style of building remaining. (© Historic England Archive)

Opposite below: Gloucester Street, Broomhall

These houses on Gloucester Street in the centre of Sheffield are part of a small local authority housing estate built in the early 1960s. They were built to an experimental '5M' design, with flat roofs and system-built panels. They were the forerunner of the Vic Hallam houses built in the 1960s and early 1970s on council estates across Sheffield. (© Historic England Archive)

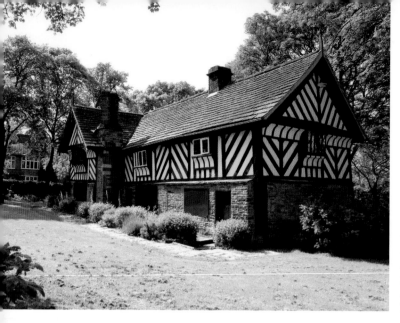

Bishop's House, Meersbrook Park

Bishop's House is one of the best examples of a timber-framed building in the city of Sheffield. It was built in the sixteenth century as a private house for the Blythe family. Various occupants followed including local families and, by the 1960s, the Meersbrook Park park-keeper. It is now a museum run by a local Friends group and is a Grade II-listed building. (© Historic England Archive)

Rollestone Estate

The Gleadless Valley estate, built in the late 1950s and 1960s, was designed as a series of small neighbourhoods set in a wooded landscape. This view looking from Blackstock Road shows the Rollestone estate and the Holy Cross Church (on the right) with its distinctive triangular shape. Mature trees and woods were retained as a green setting for the urban development. (© Historic England Archive)

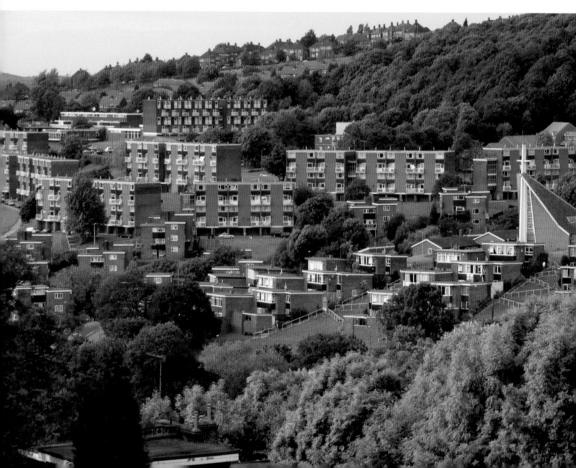

The Crofts

One of the oldest inner-city suburbs, the area known as The Crofts grew up in the early nineteenth century to house immigrant workers (at the time mostly Irish) attracted to the new cutlery- and tool-manufacturing trades. It became an area of small factories and little mesters' workshops interspersed with courts, tenement housing and shops just outside the town centre. This view from the 1920s shows a more picturesque view of the area with St Vincent de Paul Roman Catholic Church on Solly Street dominating the skyline. The chruch still stands but most of the old properties have gone. (Reproduced by permission of Historic England Archive)

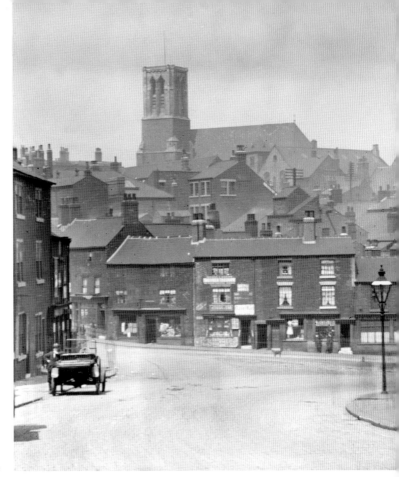

Manor Lodge, Manor Lane

Taken in the 1860s, this view shows the house and outbuildings that developed around Manor Lodge. The lodge was built within the deer park attached to Sheffield Castle and used by the earls of Shrewsbury. It was one of the houses where Mary, Queen of Scots was held. By the time of the picture the area was owned by the Duke of Norfolk and the formal park was being developed piecemeal for housing and industry. A small hamlet with coal mining, other industry and farming had grown up around the old lodge. (Reproduced by permission of Historic England Archive)

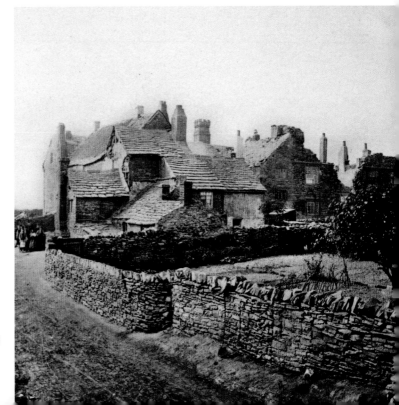

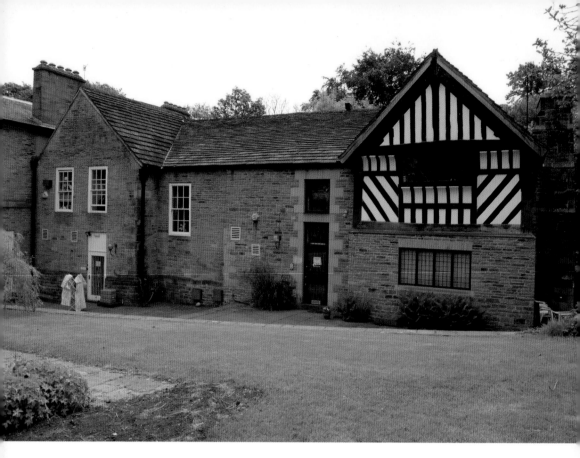

Above: Broom Hall

Shown in 2004, the oldest part of Broom Hall was built in the first half of the sixteenth century. By that time Robert Smyth had acquired the estate through marriage and made the hall his principal home. After his death, Broom Hall passed via his daughter to the Jessop family. In the middle of the eighteenth century Revd James Wilkinson inherited the hall and added another wing – the eastern one – to the house. In the nineteenth century the hall was subdivided into separate houses and used as a private school and farmhouse. The estate around the hall was sold off and laid out as the upmarket suburb of Broomhall. By 1970 the Tudor wing of the hall was in danger of being demolished for redevelopment, but planning permission was refused and in 1973 it was bought privately and restored as a private home by the world-famous cutlery designer David Mellor. (© Historic England Archive)

Opposite above: Norfolk Lodge

Taken in 1938, this aerial photograph shows the still mostly rural setting of Norfolk Lodge, once home to the Duke of Norfolk. Jervis Lumb and Norfolk Park, gifted to the people of Sheffield by the duke, is on the right. The image shows the range of buildings and the formal gardens and avenue of trees associated with a grand residence. The house still stands, but is surrounded by modern residential development.

Opposite below: Whiteley Wood Park

This postcard shows a row of ivy-covered cottages in Whiteley Wood Park on the western edge of Sheffield. It was taken in the early part of the twentieth century, showing a semi-rural setting in a leafy suburb. The cottages look in good repair but would probably have had outside midden toilets and perhaps no running water inside. (Reproduced by permission of Historic England Archive)

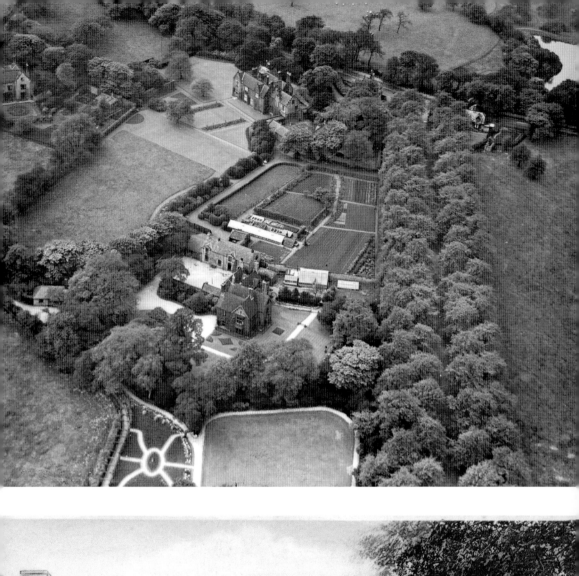

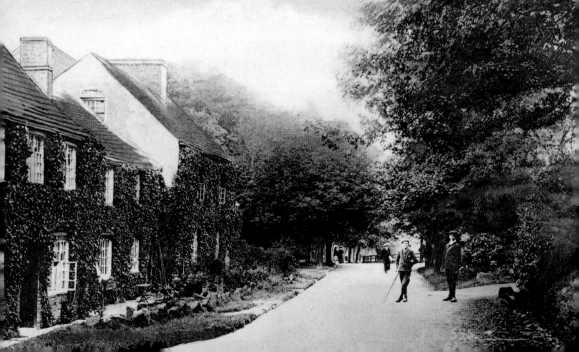

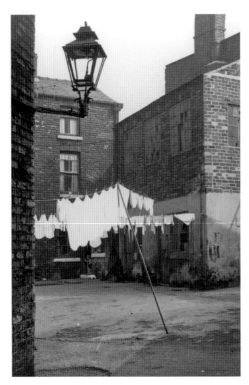

Left: Brightmore Street
This is a typical view of the old residential and industrial area around the Netherthorpe area of Sheffield that had grown rapidly in the nineteenth century. Shown here in 1957, it shows one of the courts in Brightmore Street on washday. Brightmore Street and much of the surrounding area was demolished soon after this picture was taken. The area was redeveloped in the 1960s and one of the tower blocks (near Brook Hill roundabout) is called Brightmore. The others are Adelphi and Wentworth, which are also local names. (Reproduced by permission of Historic England Archive)

Below: View of the City
Looking northwards from Meersbrook Park in south Sheffield, this view of the city was taken in 2004. It shows the modern skyline of tower blocks and suburbs interspersed with trees. Beyond is the hill up towards Wharncliffe and Grenoside in the north of the city. Immediately below lie Heeley, Sharrow and Abbeydale. (© Historic England Archive)

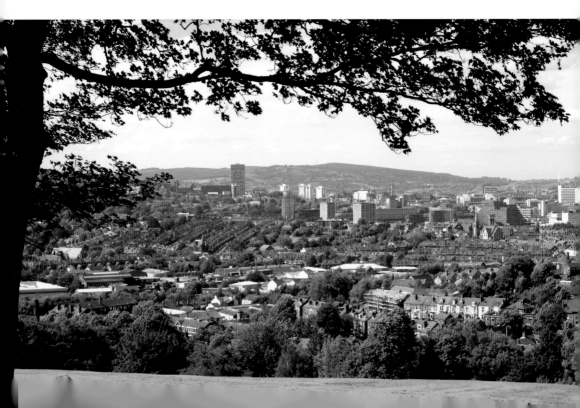

Sports, Recreation and Leisure

Home to the world's oldest Association football club, Sheffield and Sheffielders have pursued and enjoyed many sports and leisure activities over the years. The city has produced world-class athletes and sportspeople and has some first-class facilities as well as being the home to the largest UK multisport training facility at the English Institute of Sport. Historically it had many theatres, concert halls and picture palaces and still has the Lyceum and renowned Crucible theatres in the heart of the city. Major venues include the City Hall and the Sheffield Arena in the Don Valley.

Bramall Lane
Taken in 1933, this aerial shot shows Sheffield United's Bramall Lane football ground, which at the time also incorporated the Yorkshire county cricket ground. It shows a pre-Second World War view of densely packed terraced housing and a sports ground without stands or even a car park. (© Historic England Archive. Aerofilms Collection)

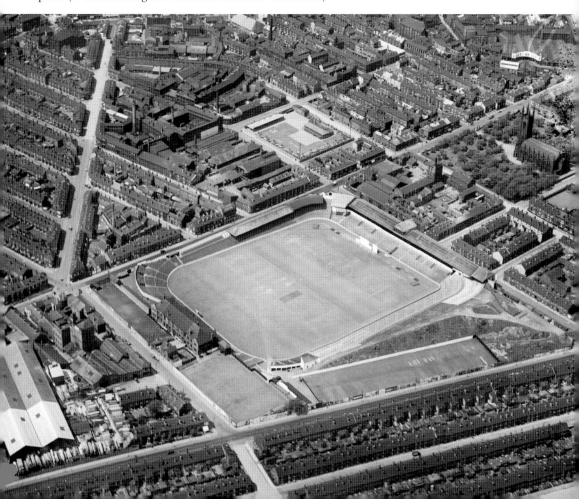

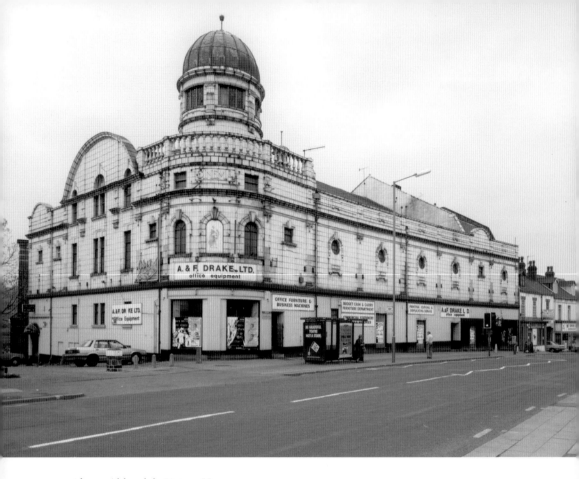

Above: Abbeydale Picture House

The Abbeydale Picture House, later known as the Abbeydale Cinema, was opened in 1920 by the Lord Mayor of Sheffield. With its mahogany and velvet seats and mosaic floor, it was described as the most luxurious cinema in Sheffield and could seat over a 1,000 people. The building also included a ballroom and billiard hall. It closed as a cinema in 1975 and was listed in the 1990s as one of the few remaining examples of an early cinema complex. Its restoration continues and it is now a popular community-run events venue. (© Crown copyright. Historic England Archive)

Opposite above: Don Valley Stadium

Built for the 1991 World Student Games and pictured here in 2004, the Don Valley Stadium had an international standard running track and other sports facilities. It played host to the Sheffield Eagles rugby team and open-air concerts as well as athletic events. However, despite a campaign to keep it open, it was closed and demolished in 2014. In so many ways this was a sad loss, though the structure was never quite good enough. (© Historic England Archive)

Opposite below: Owlerton Stadium

The Owlerton Stadium in the centre of the picture still plays host to greyhound and stock-car racing, as well as being the home of Sheffield Tigers Speedway. This view, taken in the mid-1930s, shows the track and open stands in an area that is just being developed. Just a few decades previously much of this was open countryside. (© Historic England Archive. Aerofilms Collection)

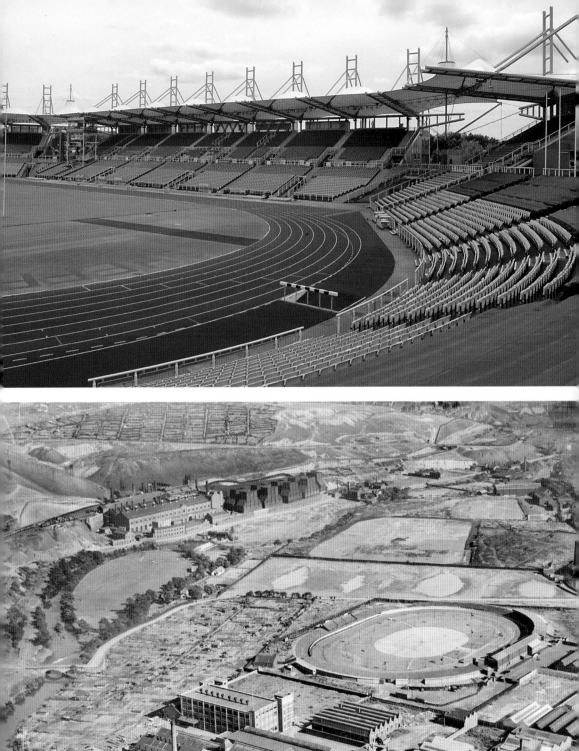

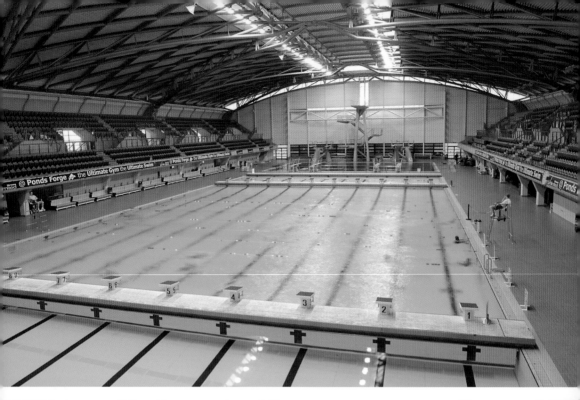

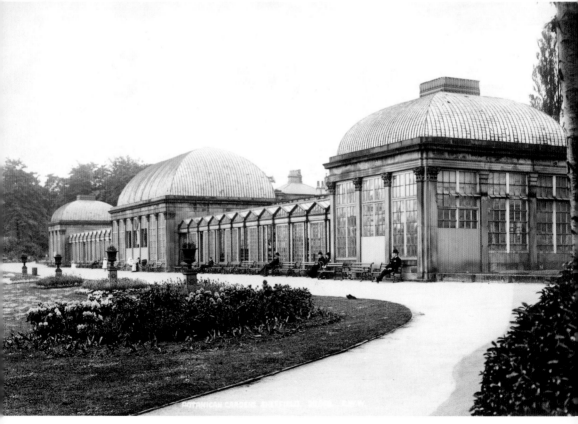

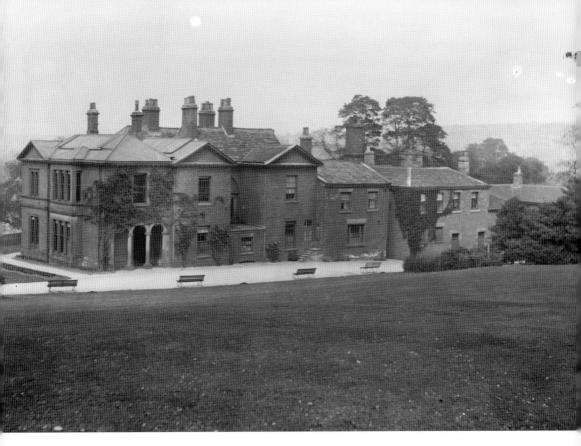

Above: Meerbrook House

Meersbrook House, built in the eighteenth century and extended in the early nineteenth century, is situated at the corner of Meersbrook Park. It is a Grade II-listed building. The house and park were sold to Sheffield Corporation in 1886, and in 1890 the John Ruskin Museum moved into the building until 1953. For the following sixty years, it was then the offices for Sheffield City Council's Recreation Department, then Leisure Services and latterly the Parks and Countryside Department. This view, taken in 1894, is easily recognisable today as the building has little changed. The building is now being used by the local community.

Opposite above: Olympic Swimming Pool, Ponds Forge International Sports Centre

The Ponds Forge International Sports Centre was built in 1991 for the World Student Games. This view shows the international standard swimming pool with spectator galleries; it has hosted numerous national and international championships. The complex, with a gym, conference facilities and a leisure pool, is on the corner of Commercial Street and Sheaf Street. (© Historic England Archive)

Opposite below: Sheffield Botanical Gardens

This black and white photograph taken around 1900 shows the glass pavilions at the Botanical Gardens, Clarkehouse Road. These iconic structures, built in the 1830s, are Grade II* listed. They are some of the first examples of curvilinear glass structures ever built, but for many generations of Sheffielders they are perhaps best remembered as housing parrots, piranhas and exotic plants. Today, they house plants from around the world. (Reproduced by permission of Historic England Archive)

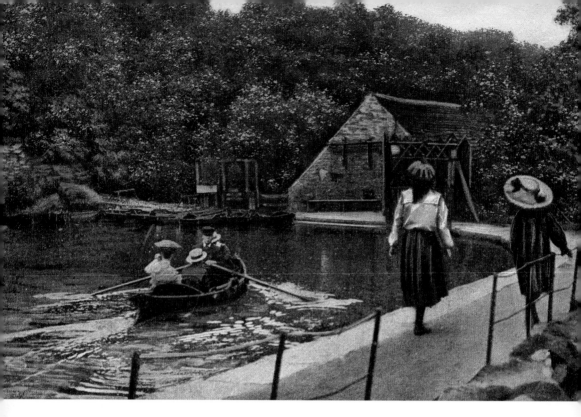

Above: The Boating Lake

The boating lake shown in this photograph from the early 1900s in Endcliffe Wood Park was created from one of the old dams that powered watermills along the valley. This image of a well-wooded valley is probably of Forge Dam, a popular place for rowing boats well into the twentieth century until the dam silted up. It still has its adjacent café and playground. (Reproduced by permission of Historic England Archive)

Opposite above: Barker's Pool Garden

This small feature known as Barker's Pool Garden, with its fountain and seating area, was created in the early twentieth century after the old buildings had been demolished and the area redeveloped. It was located in the city centre and in this picture the Grand Hotel can be seen in the background. A smaller garden still occupies the site and is overlooked by an office complex that replaced the Grand Hotel, known as Fountain Precinct. (Reproduced by permission of Historic England Archive)

Opposite below: Firth Park

This view along one of the paths to the lodge and pavilion in Firth Park is familiar to generations of Sheffield people. Firth Park was created in 1873 from 37 acres of the Page Hall estate, which the industrialist Mark Firth had purchased. It was opened in 1875 by the Prince of Wales. Firth Park gave its name to the suburb that grew up around it in the 1920s and 1930s. (Reproduced by permission of Historic England Archive)

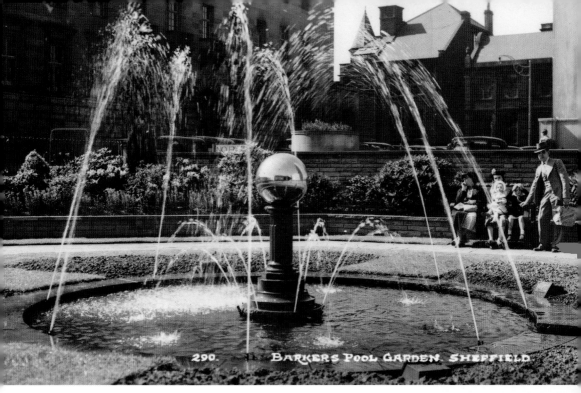

290. BARKERS POOL GARDEN. SHEFFIELD

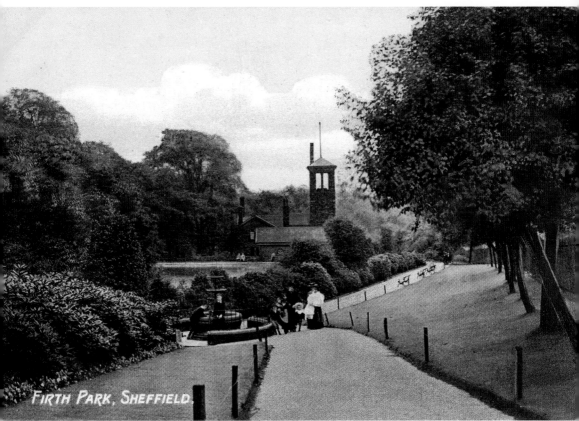

FIRTH PARK, SHEFFIELD.

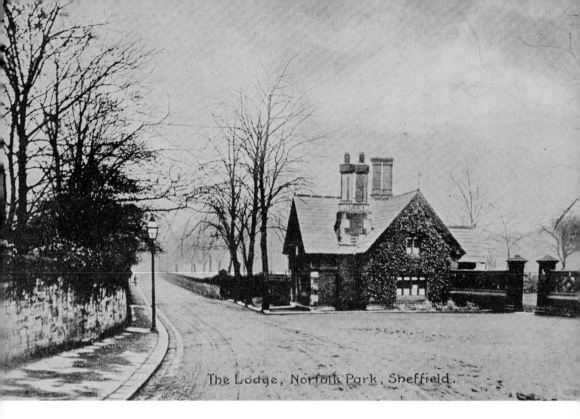

The Lodge, Norfolk Park, Sheffield.

Above: Norfolk Park Entrance Lodge

In the early 1840s, when the public park was being set out, the entrance lodge for Norfolk Park was built in the Tudor Revival style. It is now a Grade II-listed building. The park was created by the Duke of Norfolk, on land he owned, and opened to the public in 1848. This is also a listed 'Heritage Park and Garden' (Grade II*), partly due to it being an early example of a municipal park but also because of the avenues of turkey oaks and limes that run through the park from Granville Road to Guildford Avenue. (Reproduced by permission of Historic England Archive)

Opposite above: Endcliffe Wood Park

This scene of the path through Endcliffe Wood Park dates from the early twentieth century. The park was opened to the public in 1887 to commemorate Queen Victoria's Golden Jubilee, when an additional 9 acres of woodland were purchased to extend the walk up through the valley as one of Sheffield's major recreational greenways. (Reproduced by permission of Historic England Archive)

Opposite below: Rivelin Valley

Taken in the early twentieth century, this is a view of one of the waterfalls in Rivelin Valley. It is a coloured postcard, popular as a souvenir of a day out in the countryside above Malin Bridge to the north of Sheffield. At the time the image was taken it would have been outside the city boundary but still accessible by tram or by walking from Hillsborough.

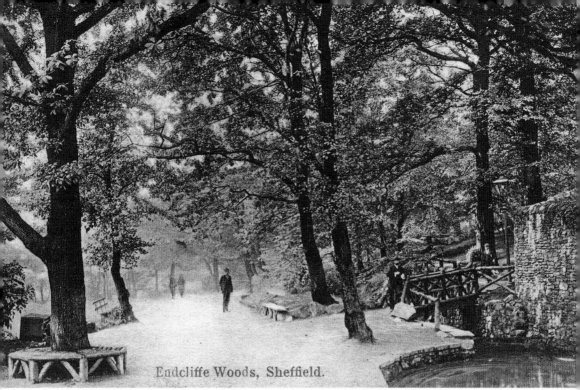

Endcliffe Woods, Sheffield.

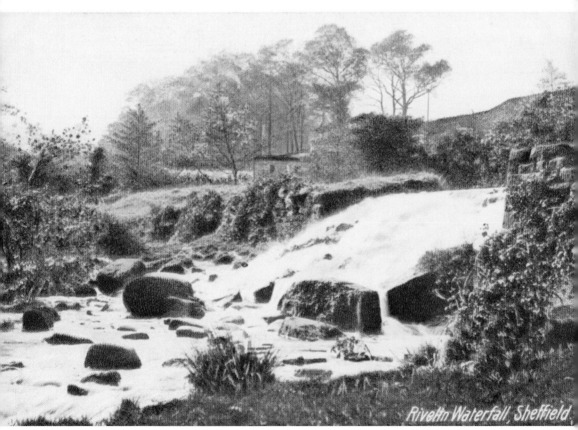

Rivelin Waterfall, Sheffield

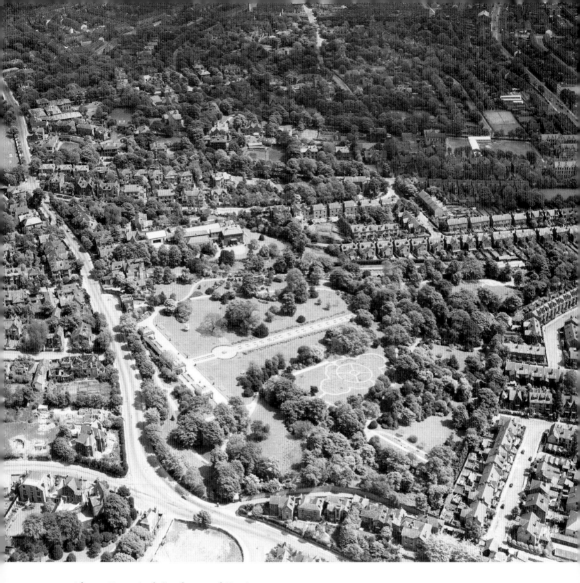

Above: Botanical Gardens and Environs

This aerial view of the Sheffield Botanical Gardens and the surrounding area was taken in 1947. It shows the layout of the gardens and the Victorian suburbs that grew up around it. The garden was designed by Robert Marnock in the gardenesque style on 19 acres of farmland purchased from the Wilson family. It opened in 1836 and was funded through money raised by the Sheffield Botanical and Horticultural Society. The whole site, now freely open to the public, was recently and superbly refurbished. (© Historic England Archive. Aerofilms Collection)

Opposite above: Hillsborough Park

This postcard of Hillsborough Park taken in the early twentieth century shows the ornamental pond with the bandstand in the background. The park was created from the private garden of Hillsborough Hall that was built for Thomas Steade in 1779. The park and building were named in honour of Thomas Steade's patron, the Earl of Hillsborough, whose home of the same name is now the seat of the Northern Irish Assembly. The hall and grounds were sold to Sheffield Corporation in 1892. The hall is now the local library. (Reproduced by permission of Historic England Archive)

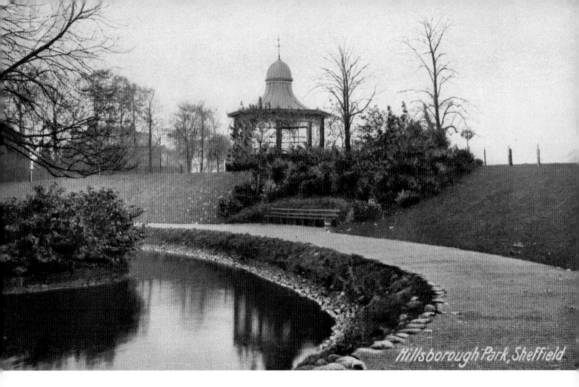

Below: Crucible Theatre
This view of the main auditorium of the Crucible Theatre is familiar to millions who watch the World Snooker Championships, which take place here. The theatre, which opened in 1971, was designed by Renton Howard Wood Associates. It was the new home of the Sheffield Repertory Company. When it was built the acoustics and design were considered to be one of the most advanced in Europe. (© Historic England Archive)

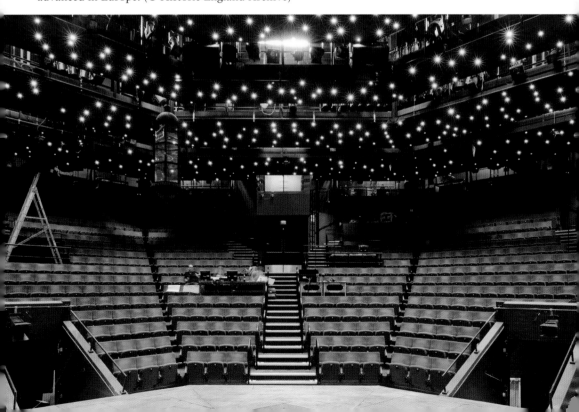

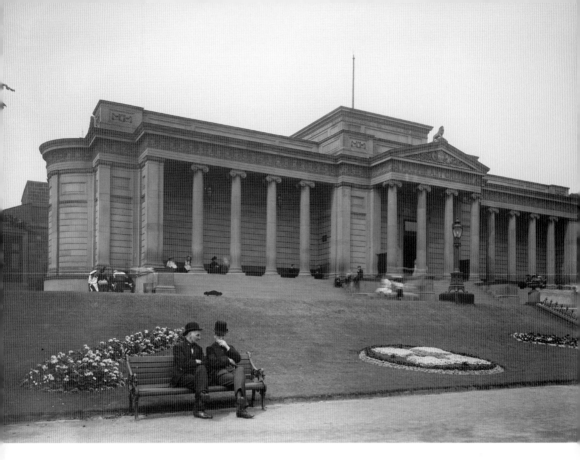

Above: Mappin Art Gallery

The Mappin Art Gallery, seen here at the end of the nineteenth century, shows the original building that was built between 1886 and 1888. John Newton Mappin left money in his will together with his art collection to create an art gallery that would be open and free to the public. The gallery was opened in July 1887 by Sir Frederick T. Mappin, who also donated pictures to the collection. These bequests became the basis of the city of Sheffield's art collection. A new City Museum was built onto the Mappin Gallery in 1937. The building remains in Weston Park but has undergone several internal transformations since. (Reproduced by permission of Historic England Archive)

Opposite: Merlin Theatre

In this photograph from 2004 we see the Merlin Theatre in the heart of Nether Edge. The Merlin is a small independent theatre built in the grounds of Tintagel House in Nether Edge and has a 204-seat auditorium with several performance rooms for music and drama. (© Historic England Archive)

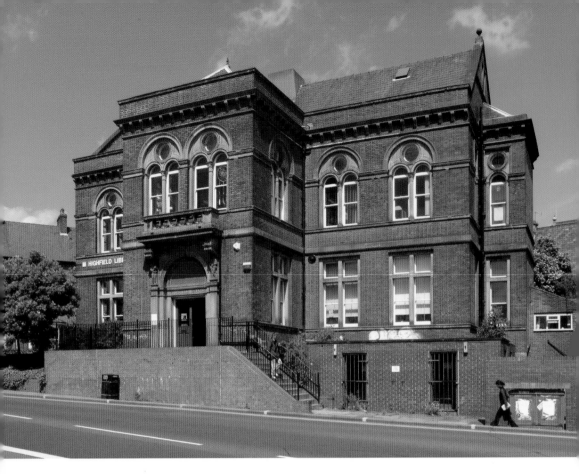

Above: Highfield Library

Along with Upperthorpe Library, Highfield Library on London Road was one of the first to be built by the city council (formerly the Sheffield Corporation) as a public library for the people of Sheffield. They were designed by the same firm of architects (E. Mitchell Gibbs). Highfields was built in 1876 and incorporated a house for the librarian next door. The fields on which it stands were playing fields and the first home of Sheffield Wednesday football club. (© Historic England Archive)

Opposite above: Lyceum Theatre, Tudor Square

The Lyceum Theatre opened in 1897. It was designed by William J. Sprague with a capacity of 3,000. It replaced an earlier wooden theatre known as the City Theatre. By the early 1970s it was facing demolition and, as part of the campaign to save the building, it was Grade II listed. This was primarily because of the auditorium and internal decoration. By this time the building was being used as a venue for concerts. This view shows the refurbished theatre, which was partly rebuilt and reopened in December 1990. (© Historic England Archive)

Opposite below: Millennium Gallery

This modern construction facing Arundel Gate is part of the complex of new buildings and squares built at the turn of the twenty-first century. This was on the site of the Town Hall extension, which opened in 1977 and the 'wedding cake' registry office. These in turn had replaced an area of much older commercial properties and small factories demolished in the 1960s and early 1970s. The only one of the buildings remaining is the eighteenth-century Leader House next to the Millennium Gallery, pictured here in 2004. (© Historic England Archive)

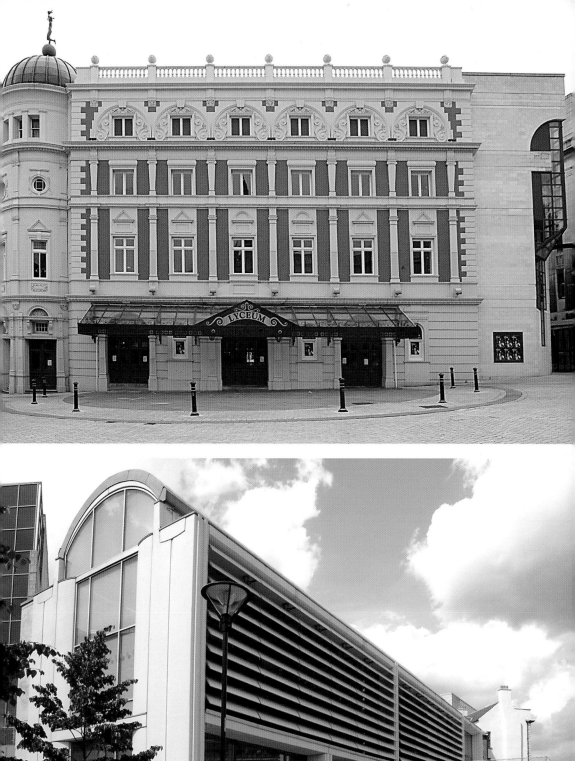
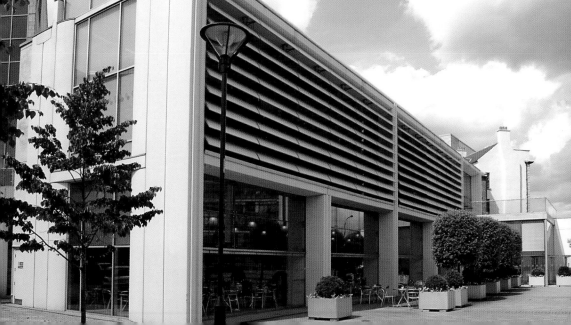

Education, Religion and Health

Sheffield is now home to two universities, two cathedrals and many churches and chapels. It also boasts high-achieving schools, pre-eminent hospitals and associated medical schools. These all had their origins in the nineteenth century and early twentieth century. Many of the institutions and establishments were founded through donations by local industrialists and businessmen who saw it as their civic duty to support philanthropic aims.

University of Sheffield and Environs
In the centre of this aerial view, taken in 1921, is the University of Sheffield. The original red-brick building, Firth Hall, was built in 1905, with the octagonal tower added in 1911. The architect was E. Mitchell Gibbs. To the left of the university is Weston Park and opposite the park is the Children's Hospital. (© Historic England Archive. Aerofilms Collection)

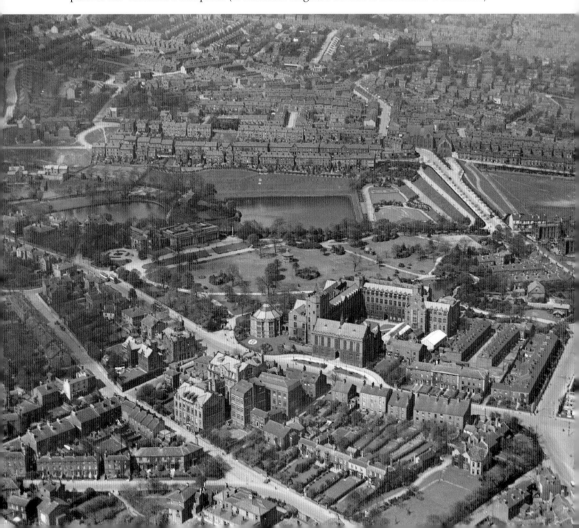

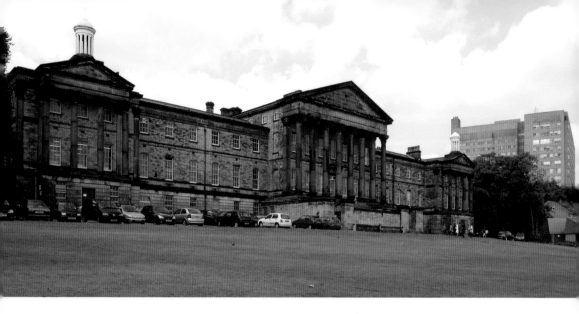

Above: King Edward VII Upper School, Glossop Road
This 2004 photograph shows the King Edward VII Upper School on Glossop Road. It was formerly Wesley Proprietary Grammar School, Wesley College, and King Edward VII Grammar School. This massively imposing creation was built from 1837 to 1840 by William Flockton and was exceptional for a school project of the time – a colossal twenty-five-bay width, central seven-bay entrance and eight huge Corinthian columns plus a grand outer staircase. Alterations in the early 1900s removed dormitories as Wesley College merged with Sheffield Royal Grammar School, forming King Edward VII Grammar School for boys. The final eleven-plus intake was in 1968, when the school went comprehensive. (© Historic England Archive)

Below: Jewish Cemetery, Blind Lane
In the 1870s land was acquired by the Sheffield Hebrew Congregation for a Jewish Cemetery in Blind Lane, Ecclesfield. The cemetery is still in use today. This view from 2002 was taken from inside the cemetery and shows the chapel and main entrance. (© Historic England Archive)

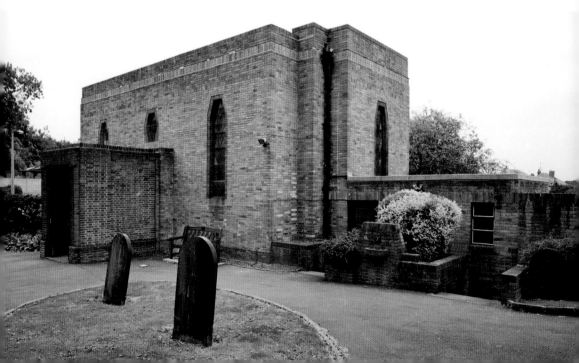

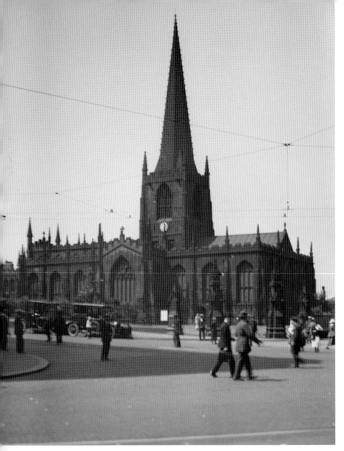

Left: Cathedral Church of St Peter and St Paul
Taken at the turn of the twentieth century, this view of the Anglican cathedral shows the church seen from the bottom of Fargate. It was dedicated to St Peter and St Paul by Thomas de Furnival when he had a church built on the site in 1280. Since then parts of the church have been rebuilt and extended many times, though some parts from the 1400s rebuild still survive. (Reproduced by permission of Historic England Archive)

Below: Christ Church, Attercliffe
The Anglican Christ Church was built in 1826 to accommodate the increasing population of Attercliffe. This photograph showing a group outside the churchyard was taken at the turn of the twentieth century. The church was destroyed in 1940 during the Blitz. Many other old buildings have since been lost from the area. (Reproduced by permission of Historic England Archive)

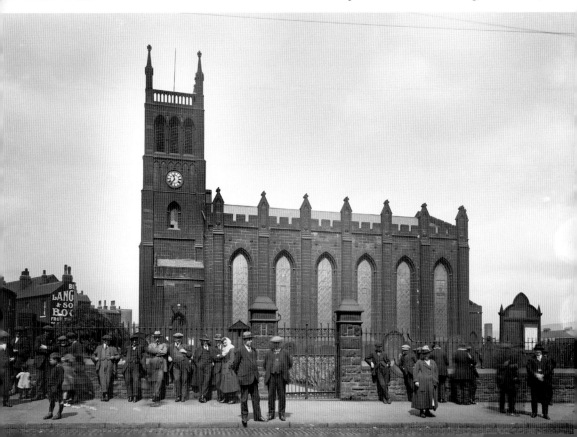

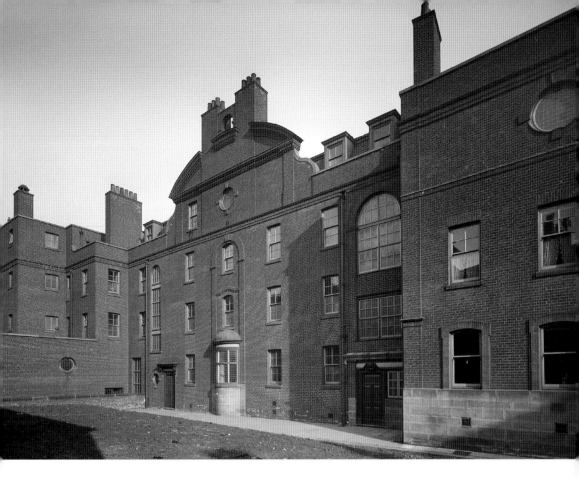

Royal Hospital Nurses' Home, Eldon Lane
The foundation stone for the Royal Hospital Nurses' Home on Eldon Lane was laid by the Duke and Duchess of York on 11 May 1895. This was on the same day that they opened the new York Wing of the Royal Hospital. This picture, taken in 1897, shows the completed nurses' home, which was situated conveniently at the back of the hospital. (Reproduced by permission of Historic England Archive)

Sheffield Royal Hospital
This interior view, taken in 1897, shows the outpatients waiting room in the Sheffield Royal Hospital. Note the rows of wooden forms and the high-vaulted ceilings. The hospital was situated on West Street and started life in late 1832 when Westfield House was purchased and opened as the Sheffield Public Dispensary. The dispensary became a hospital in the late 1860s as the building and facilities expanded. It was renamed the Royal Hospital in 1895 and closed in the late 1970s. The hospital was mostly demolished in the 1980s. (Reproduced by permission of Historic England Archive)

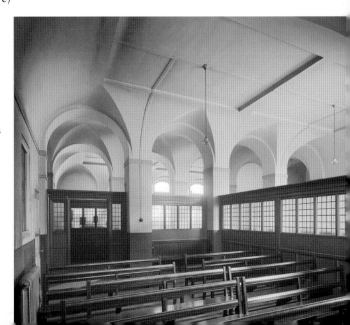

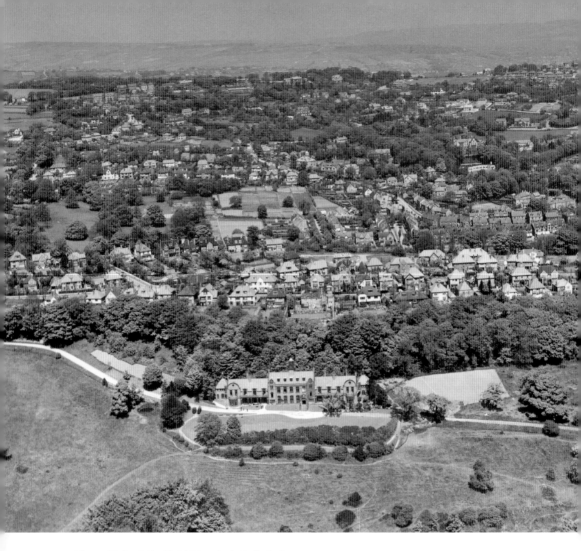

Above: United Sheffield Hospitals Rehab Centre
The United Sheffield Hospitals Rehabilitation Centre (1943–58) is shown in the foreground of this 1951 picture. It opened as the Woofindin Convalescent Home at the beginning of the twentieth century. In May 1958, Whiteley Wood Clinic opened in the premises of the former rehabilitation centre as a unit of Sheffield University's new Department of Psychiatry, with close links to the local hospitals. (© Historic England Archive. Aerofilms Collection)

Opposite above: City Road Cemetery
The ornate and imposing gatehouse and lodges of the City Road Cemetery are shown here in 1897. They were designed by architects Hatfield & Son. The cemetery, which covers around 50 acres, was laid out on land purchased from the Duke of Norfolk by the Sheffield Township Burial Board in 1878. It was taken over by Sheffield Corporation and is still one of the main municipal cemeteries for Sheffield. The gatehouse and offices, shown in the picture along with the grounds, are Grade II listed. (Reproduced by permission of Historic England Archive)

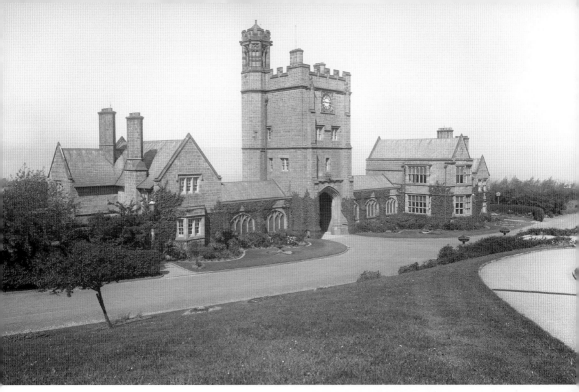

Upper Chapel, Norfolk Street
This interior view of the Unitarian chapel (known as the Upper Chapel) on Norfolk Street in the centre of Sheffield shows the wooden pews and gallery. The chapel originates from 1700 but was extended in the mid-nineteenth century, and a vestry was added in 1900. The building is set back from Norfolk Street and has a courtyard area with a side entrance to Norfolk Row.
(© Historic England Archive)

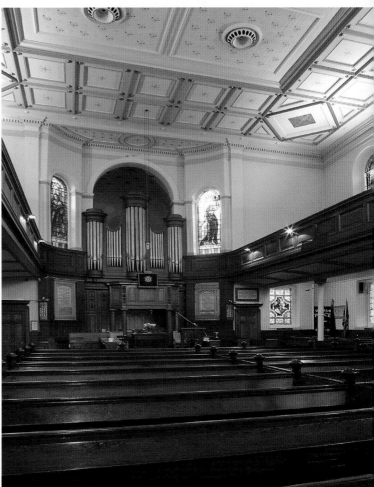

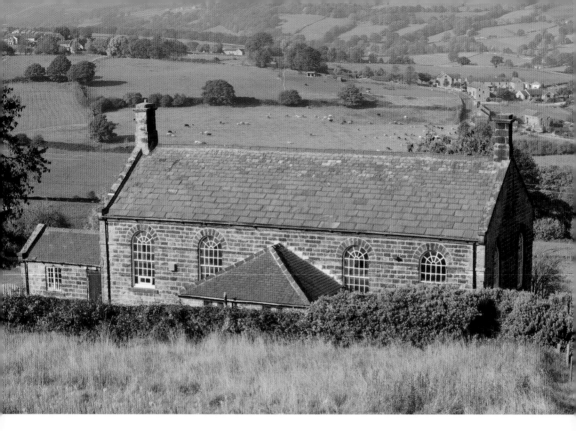

Above: Underbank Schoolroom
Underbank Schoolroom was opened in 1853 as both a day school and a Sunday school. The Grade II-listed building at the corner of Stopes Road and Riggs Low Road is still in its rural setting. Close by is Underbank Chapel and an adjoining house, which are also Grade II listed. (© Historic England Archive)

Opposite above: St Paul's Church, Norfolk Street
Taken from the bottom of Cross Burgess Street in 1914, the imposing tower of St Paul's Church can be seen in the centre with the slender tower of the Town Hall to the left. St Paul's Church was demolished in 1937 and the site bought by the city council for redevelopment. The bells from the church were transferred to a new St Paul's on the Arbourthorne estate. That church has also been demolished. (Reproduced by permission of Historic England Archive)

Opposite below: Brunswick Chapel
This 1904 image shows the Brunswick Wesleyan Chapel, built in 1834 on South Street at the bottom of the Moor. At the time it was considered to be the most elegant of Sheffield's new chapels. It closed in 1943 and the congregation transferred to Trinity Church at Highfields. The inner ring road now runs over the site. (Reproduced by permission of Historic England Archive)

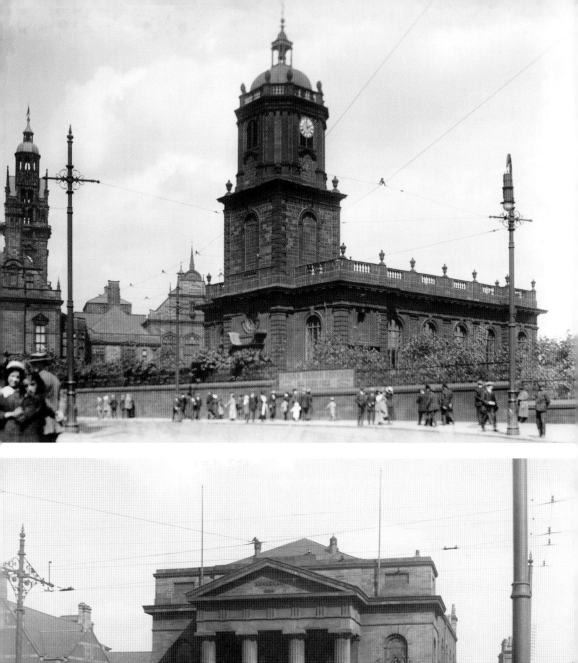

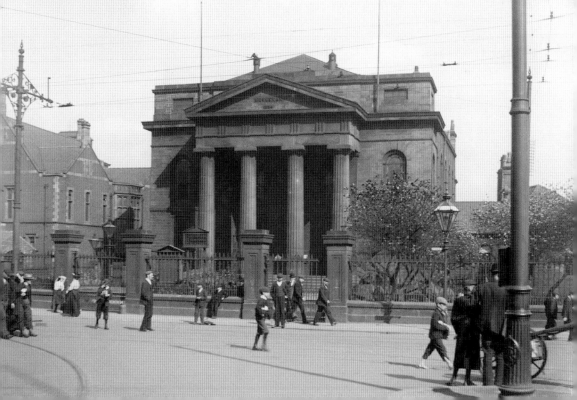

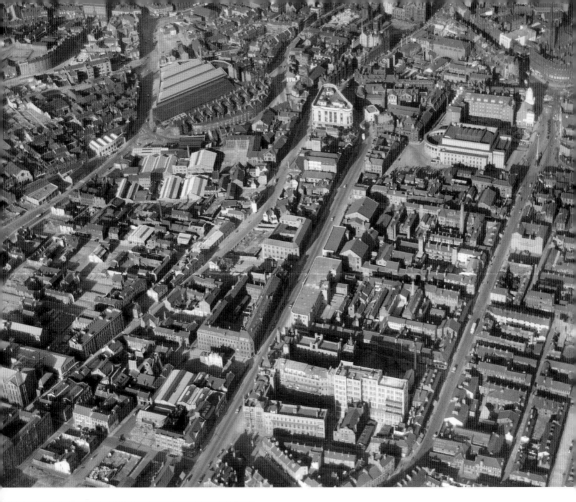

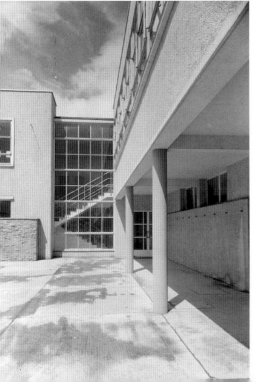

Above: West Street and Environs
This aerial view of the area around West Street, taken in 1937, shows the former Royal Hospital at bottom centre. The hospital was funded through subscriptions and was built in stages from the middle of the nineteenth century with new medical wards, surgical facilities and outpatient departments being built. In 1922 the hospital purchased the adjacent Mount Zion Chapel and converted it into a new outpatients department. It was opened in 1927 by Neville Chamberlain, the then Minister of Health. (© Historic England Archive. Aerofilms Collection)

Left: Ecclesfield County Secondary School
Ecclesfield (or Yew Lane) County Secondary School was built by the West Riding of Yorkshire Education Committee in the late 1930s. This view shows the modern style of one of the buildings. In the 1950s an extension was built that was designed by Sir Basil Spence Associates, one of only five English schools that he was commissioned to design. (Reproduced by permission of Historic England Archive)

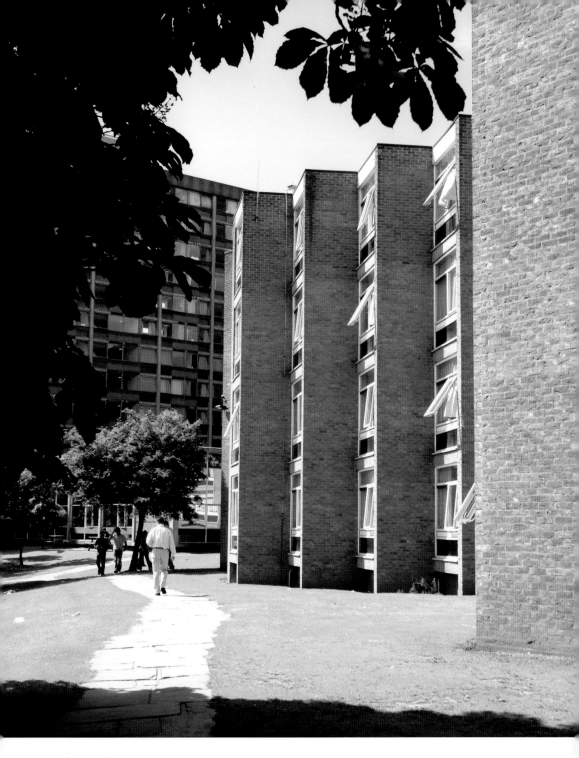

Earnshaw Hall
Earnshaw Hall was opened in 1965. It was one of the University of Sheffield's halls of residence and built around the Endcliffe Crescent area of Sheffield. It was demolished in 2005 to make way for the modern Endcliffe Student Village. This view, taken from the south-east, looks towards Sorby Hall, one of the other halls of residence. (© Historic England Archive)

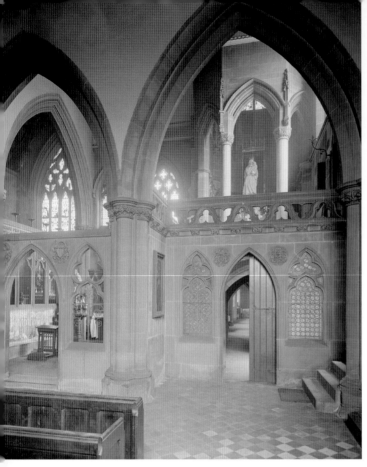

Lady Chapel in St Marie's Cathedral, Norfolk Row
This interior view of St Marie's Roman Catholic Cathedral shows the Lady Chapel. The cathedral was founded by Revd Charles Pratt and built in 1847 in the Gothic style. The architect was M. E. Hadfield, and both he and Revd Pratt are commemorated in the building. (Reproduced by permission of Historic England Archive)

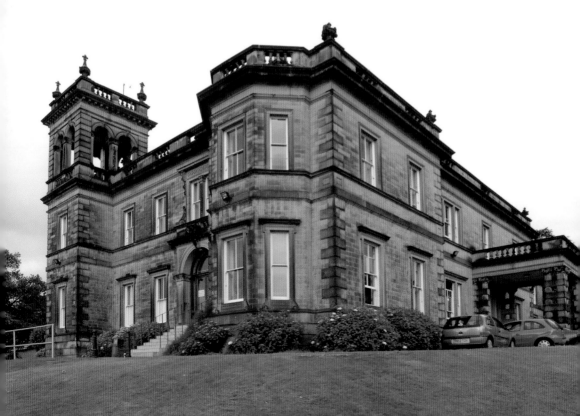

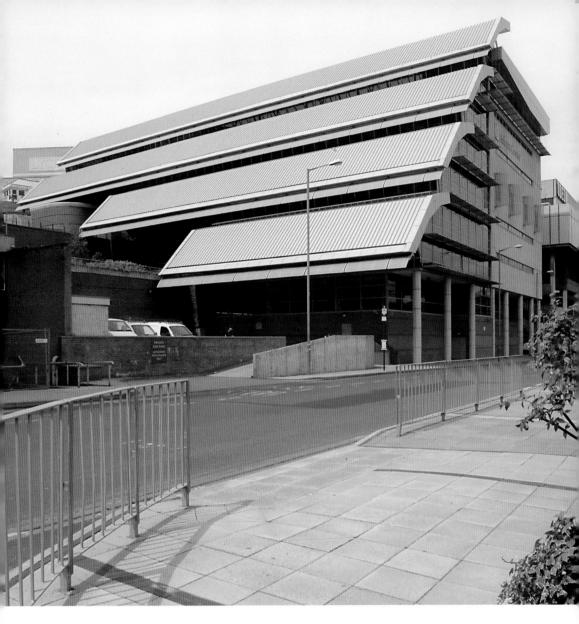

Above: Adsetts Centre, Flat Street
Part of Sheffield Hallam University's city campus, this modern building's main entrance is on Arundel Gate and is shown here in 2004. It is the university's main library and is known as the Adsetts Centre after local businessman Sir Norman Adsetts, chairman of the board of governors of the university between 1993 and 1999. (© Historic England Archive)

Opposite below: Oakbrook (Notre Dame High School)
This Italianate-style house was built in 1860 for the industrialist Mark Firth and is pictured here in 2004. It is now part of Notre Dame High School, founded in the centre of Sheffield by the Sisters of Notre Dame in the 1850s. Oakbrook became the sisters' living quarters in 1919 and a grammar school was built in the grounds in the 1930s. The city centre school remained open until the 1980s. When it was finally demolished a plague of rats appeared above ground and swamped down West Street. (© Historic England Archive)

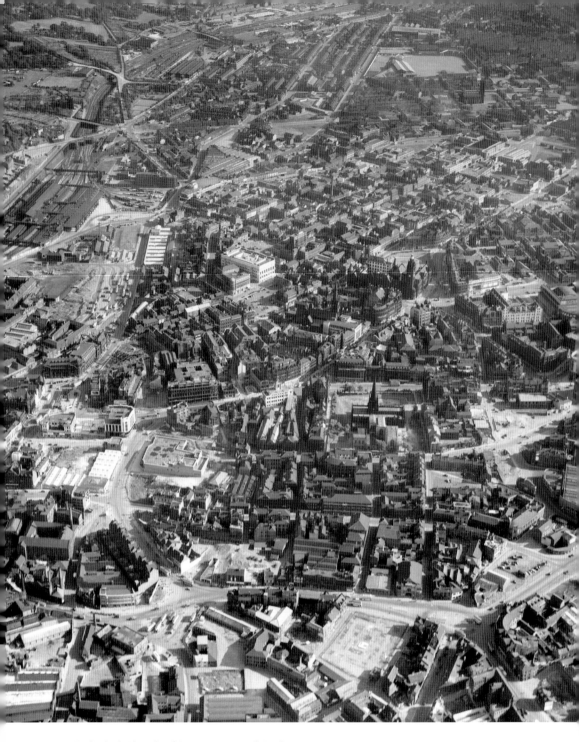

Cathedral Church of Saints Peter and Paul
Taken in 1950, this photograph of the city centre shows the Anglican Cathedral Church of Saints Peter and Paul in the centre, with St Marie's Roman Catholic Cathedral and the Methodist chapels just beyond across to the left. (© Historic England Archive. Aerofilms Collection)

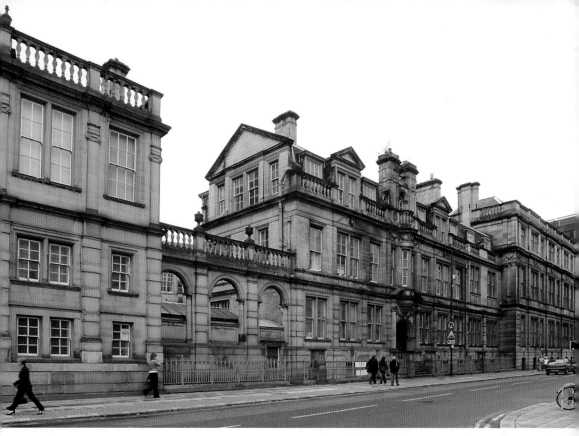

Above: Leopold Street
Originally built in 1879 as the City
Grammar School and Central Technical
School, this complex of buildings
on Leopold Street now houses bars,
restaurants and a hotel. It is pictured
here in 2004 and the interior of the
hotel still has features and photographs
that reflect its origins. In the 1960s
the building became the city council's
education offices. (© Historic
England Archive)

Right: Sheffield Islamic Centre Madina
Masjid, No. 24 Wolseley Road
Taken in 2016, this street view is
looking along Wolseley Road in the
Mount Pleasant and Lowfields area
close to the city centre. The modern
Sheffield Islamic Centre Madina Masjid
with its turquoise domes, is a major
new landmark in the city. . The Islamic
Centre was the first purpose-built
mosque in Sheffield and opened in
2006. (© Historic England Archive)

About the Archive

Many of the images in this volume come from the Historic England Archive, which holds over 12 million photographs, drawings, plans and documents covering England's archaeology, architecture, social and local history.

The photographic collections include prints from the earliest days of photography to today's high-resolution digital images. Subjects range from Neolithic flint mines and medieval churches to art deco cinemas and 1980s shopping centres. The collection is a vivid record both of buildings that are still part of everyday life – places of work, leisure and worship – and those lost long ago, surviving only in fragile prints or glass-plate negatives.

Six million aerial photographs offer a unique and fascinating view of the transformation of England's towns, cities, coast and countryside from 1919 onwards. Highlights include the pioneering photography of Aerofilms, and the comprehensive survey of England captured by the RAF after the Second World War.

Plans, drawings and reports provide further context and reconstruction artworks bring archaeological sites and historic buildings to life.

The collections are housed in a purpose-built environmentally controlled store in Swindon, which provides the best conditions to preserve archive items for future generations to enjoy. You can search our catalogue online, see and buy copies of our images, as well as visiting our public search room by appointment.

Find out more about us at HistoricEngland.org.uk/Photos
email: archive@historicengland.org.uk
tel.: 01793 414600

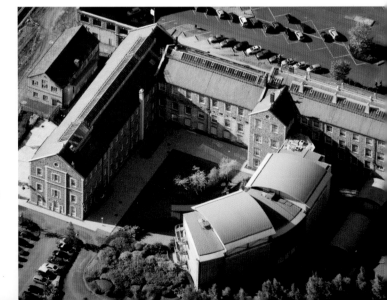

The Historic England offices and archive store in Swindon from the air, 2007.